FETISH

FASHION

UNDRESSING
THE CORSET

LARRY UTLEY

WITH AN INTRODUCTION BY
AUTUMN CAREY-ADAMME

GREEN CANDY PRESS

FETISH

FASHION

UCA
university for the **creative arts**

Fetish Fashion: Undressing the Corset
Published by Green Candy Press
San Francisco, CA

ISBN 1 931160 06 6

www.greencandypress.com

Acknowledgments:
Dark Garden Corsetry and Stormy Leather of San Francisco for their support and contribution to this endeavor. S & J of Lafayette. Rose for her meticulous attention to detail. And to the models, each and every one, for the dance of trust through the dark and light that is photography.

Design and Production: Pepper Design Studio
Cover Model: Marci
Makeup Artist: Gillian Kalisky, for models on pages 14, 15, 22, 23, 37, 88, and 89.

Printed in China by Oceanic Graphic Printing

I am often asked when my interest in corsetry began. Was it the day I ran across a photo of the amazing 13-inch waist of Ethel Granger in the Guinness Book of World Records, or during my early research about Henry VIII's courtiers? I can't say for sure. It may have even been Laura Ingalls Wilder or her contemporaries, who I read about voraciously as a child, always imagining myself in numerous red taffeta petticoats, laced up and booted, my hair curled with a slate pencil warmed on the stove. As far back as I can remember I played dress up, even if only in my imagination. I recall being taken shopping for a dress to wear as a flower girl when I was four or so. Even then I wanted a dress with a small waist. Imagine my frustration with the unnaturally high waistlines of the early 1970s.

I was to wait several years before my interest in corsets really blossomed and was given an outlet. When I was ten years old, I was given a hand-me-down costume to wear at the Renaissance Pleasure Faire in Northern California. This costume included an Elizabethan-style corset. The scooped neckline, the waist, the trim lines. I was in heaven. I wore the corset to school, claiming it helped my posture in band class. Two years later, my mother helped me to make my own corset. Although my resources were limited in the sleepy beach town of Santa Cruz, I was determined. With money in hand, I rushed

to the local fabric store and emptied it of plastic boning. If I used just enough, my newest purchase would do the trick. I moved on to packing strapping spring steel only to be cut to ribbons on its sharp edges. Eventually, some kind soul pointed me in the right direction: spring steel boning designed specifically for corset making. In no time, my mentor and I were attending the Great Dickens Christmas Fair, where I was introduced to Victorian-style corsets. In contrast to the trim lines of the Elizabethan style, Victorian corsets are shaped like an hourglass, accentuating the wearer's waist. They cover and mold the body from the bust to the hips, and can actually prevent the wearer from bending at the waist! I tried every pattern on the market and experimented with Norah Waugh's Corsets and Crinolines, scaling patterns using every method I could think of. When I think of my first ten corsets all I can do is shake my head and smile indulgently. I tried so hard!

Recently, one of my clients brought in a corset I had created for a friend of hers when I was just sixteen. Not bad, all things considered. I was amazed that the corset had been treasured for the last fourteen years and that it was still wearable. I shouldn't have been so surprised, I suppose. The first antique corset I ever purchased is still tucked away among precious old photos and dusty clothes. That corset taught me more than any fashion design book ever has, save for the first issue I ever saw of "Skin Two" magazine. This particular issue had photos of the most beautiful leather corset I have ever seen. I stared at the photos for hours, astounded by the corset's incredibly small waist measurement, trying to figure out how it was possible to create a waist so small. After hours of thought, I finally understood.

Eager to apply my newly found knowledge, I brought out the pattern paper and the muslin once again.

A year later, Dark Garden as we know it was born. That year, I met Monique Motil, who became my business partner. She too had tried all of the commercial patterns available and had pored over Corsets and Crinolines with the same fervor as I. She possessed an amazing skill for three-dimensional thinking and together we developed our first working patterns. Thinking that smaller was better, we became excited by the idea of crafting a corset with a sixteen-inch waist. We did it, and talked a mutual friend into wearing it out. That night, our friend met the incredibly talented photographer, Peter DaSilva, who arranged to photograph her in it. Soon after this initial encounter, Peter took photos of several of our friends in their corsets, and before we knew it, we had a catalog.

I often think about the reason why our interest in corsets has been renewed. After all, didn't our grandmothers and mothers fight to be freed of restrictive foundation garments? Why are we once again wearing these health-threatening torture chambers? The answer is simple: corsets are sexy. They are not uncomfortable if they fit well and have been properly made.

Corsetiers have used varying materials for their creations over the years. For instance, whalebone was used for a time. I recall my first time seeing a large piece of baleen and discovering that this was the stuff corsets were boned with. It looked so different from the whale bones I had imagined! My

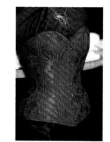

precious antique corset was boned with cardboard, another with cord exclusively. Research tells me that cane, feathers, and reeds were also implemented in the making of corsets. Some of the earliest corsets were simply made of several layers of stiffened linen. One of the most fascinating pieces of corset-related paraphernalia I've seen is a waist protector designed to save the wearer's skin from broken boning at the waist. This extra piece would have been stitched into the inside of the corset, placing an additional layer of unsullied boning closer to the wearer's body. The waist protector would also strengthen the corset, adding to the life of a fairly costly and utterly necessary garment.

Today, good quality boning is fairly easy to find. Spring steel is the choice of most corset makers, although one reputable corsetier uses metal cable, which is very flexible and strong. Faux corset makers use plastic feather boning, guaranteed to crumple and offer little or no support. The best corsetiers design with care: every fabric choice and stitch is geared to creating a sumptuous fit.

I credit Pop icon Madonna and Paris fashion designer John Paul Gaultier with bringing the corset back into the public consciousness. Madonna—who is nothing if not sexy and self-confident—wore Gaultier's corsets with so much style that we all wanted to be like her. To this day, I hear her name when I wear a corset out in public. Gaultier recreated the corset, bringing to it a modern sensibility while evoking memories of a bygone era. Designers such as Christian LaCroix, Vivienne Westwood, Dolce and Gabanna, and Thierry

Mugler have all made their mark in the world of corsetry as well. Today, Stella McCartney, designer for Chloe, has had a hand in the current resurgence of corset wearing. Over time, I've watched the general public's interest in corsets steadily increase, often inspired by popular movies: Dangerous Liaisons, Titanic, Quills, Age of Innocence, and most recently, Moulin Rouge.

Unfortunately, gossip about the making of Moulin Rouge has lead to another misconception about the dangers of corset wearing. Rumor had it that Nicole Kidman broke a rib due to the corsets she wore, when in fact it was the movie's rigorous dance routines that caused the injury. No one has mentioned the damage her shoes did to her knee in the same movie. Though they have the same potential to damage the wearer, high heels have yet to bear the same stigma as corsets.

The misconceptions that some people have about corsets can be quite startling. "Women fainted constantly. No one was ever without her smelling salts." Can you imagine wearing six petticoats, a chemise, a corset, a corset cover, a blouse, and a bodice in any weather and never feeling faint? "They had ribs removed, you know." Honestly, in an age before anesthesia or penicillin, how often do you suppose women really had this surgery? Perhaps one woman went through the surgery, though I have yet to read about it. What I do know is that women had the vapors—something not many people know about. Having the vapors is a terrible condition comprised of not being able to either pass gas or burp because of society's constraints; corsets had nothing to do with the above-mentioned effects.

I feel deeply indebted to the women who led the revolution against constraining undergarments. I applaud the revolutionary

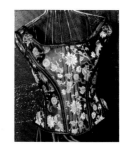

women who burnt their bras in the 70s. So why do I still enjoy wearing the type of garment my grandmother found so repressive? Well, because I can. Thanks to those courageous women, I can choose to wear a corset any time I want to—or not. No one dictates that I must wear a corset every day. I can enjoy the sleek, sexy fit of a corset whenever I want. We certainly have come a long way, baby.

The book you are about to read proves just that. Fetish Fashion: Undressing the Corset showcases a unique collection of corsets—and the people who wear them. Photographer Larry Utley has captured the essence of what truly makes a corset great. Along with good craftsmanship, it's the people who wear them that bring corsets to life. As an avid designer and wearer of corsets, I have thoroughly enjoyed contributing to, and looking through, Fetish Fashion: Undressing the Corset. Whether you are a corset wearer, designer, or admirer, this book is a must have.

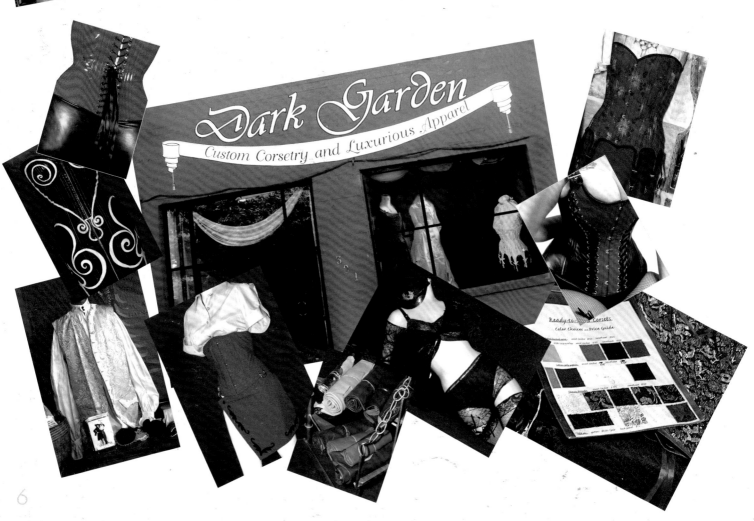

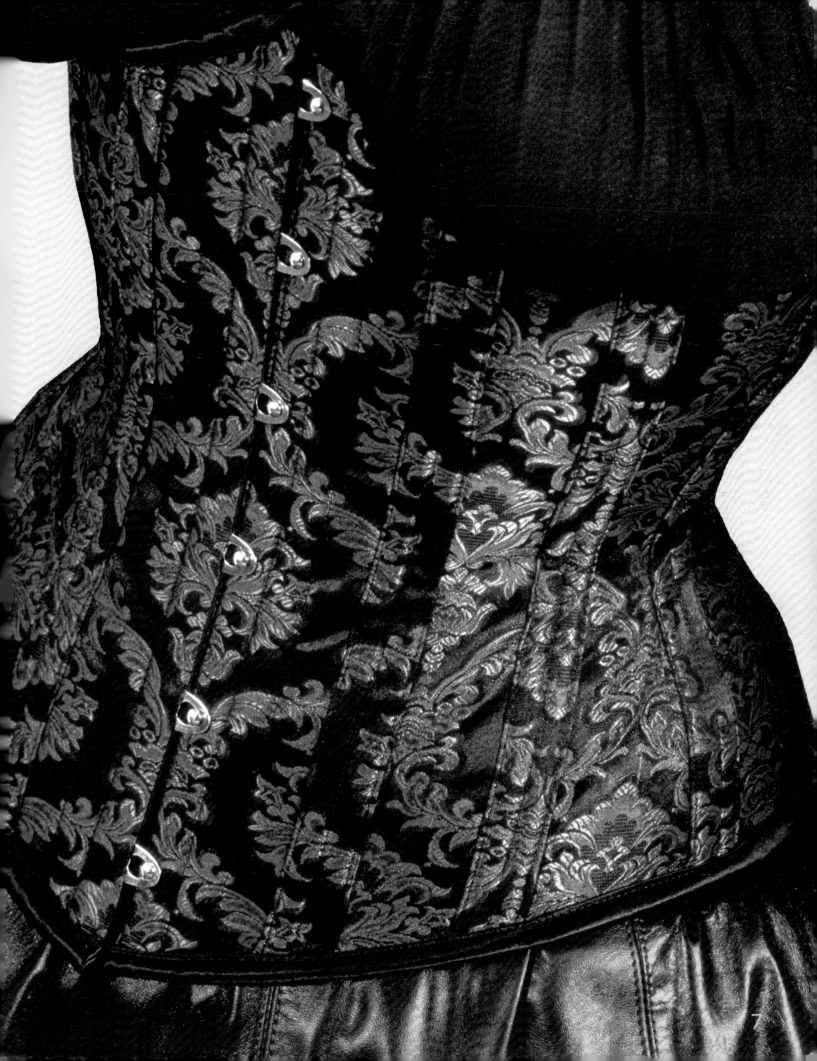

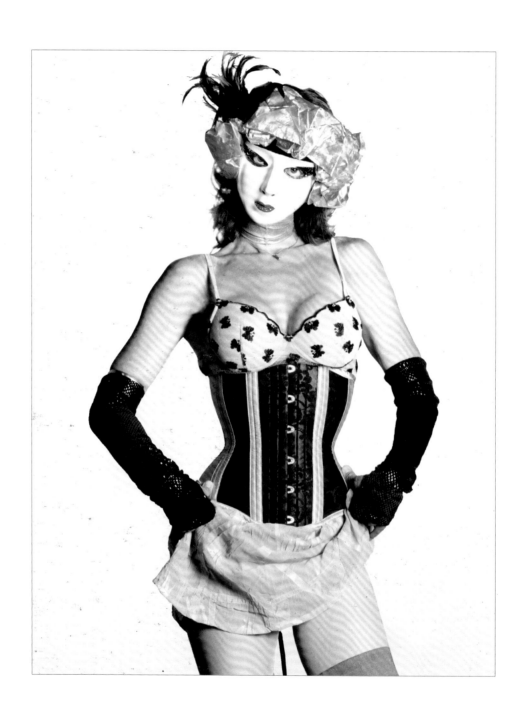

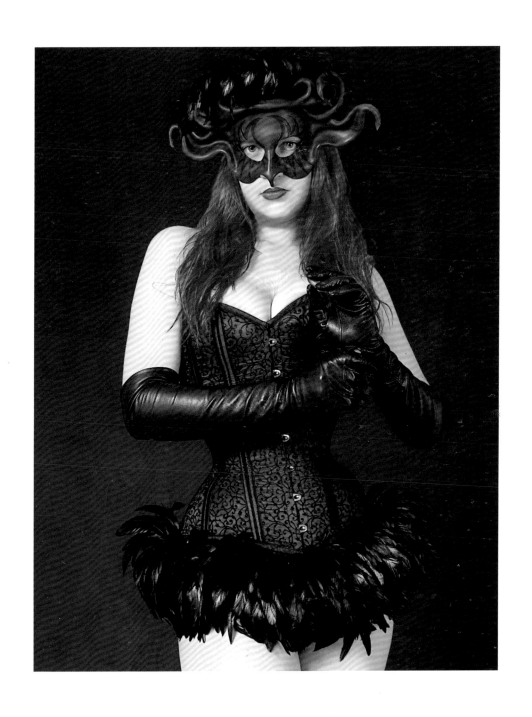

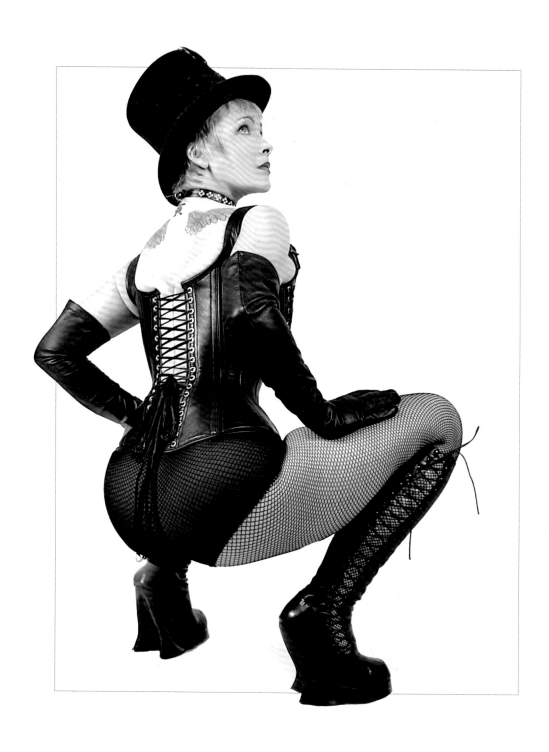

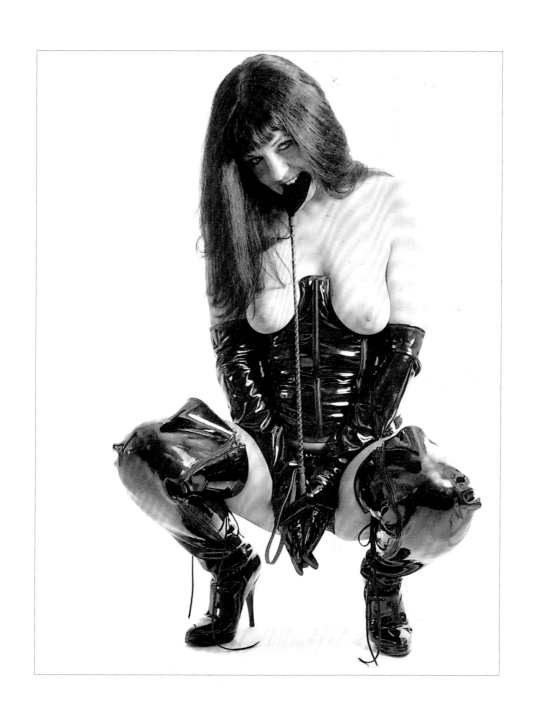

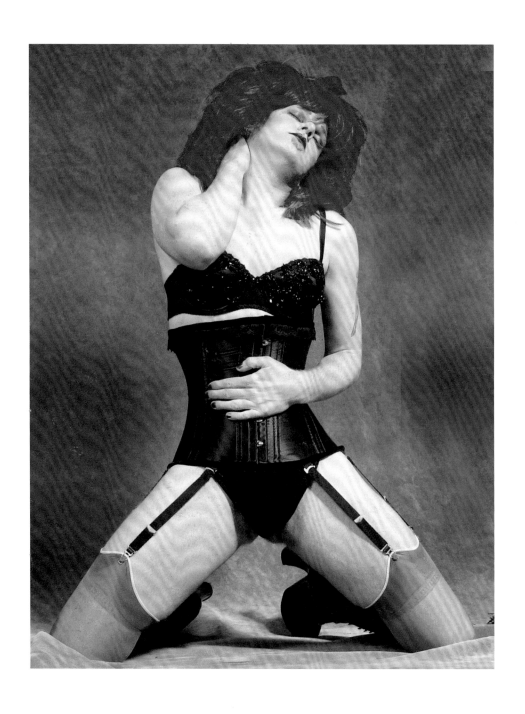

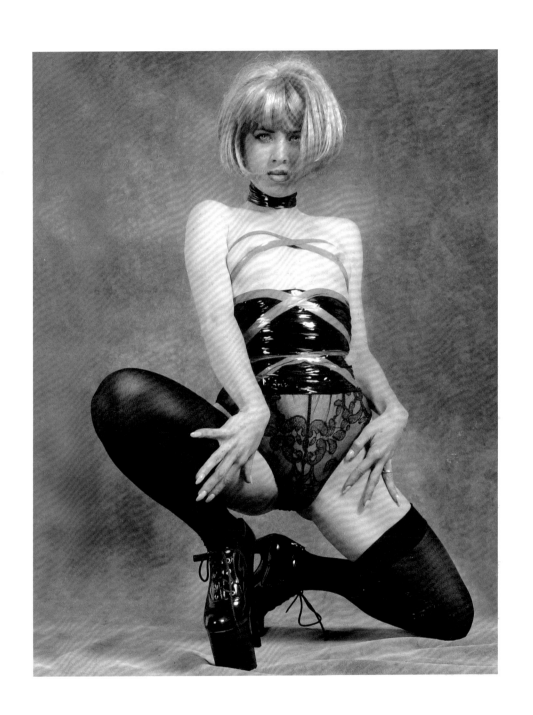

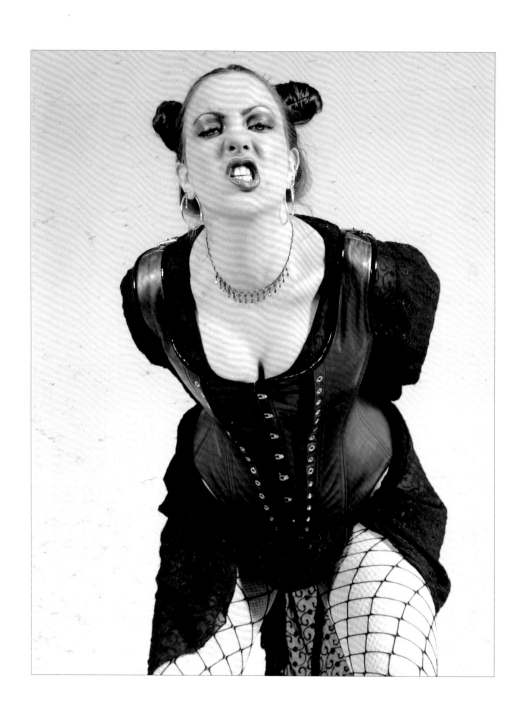

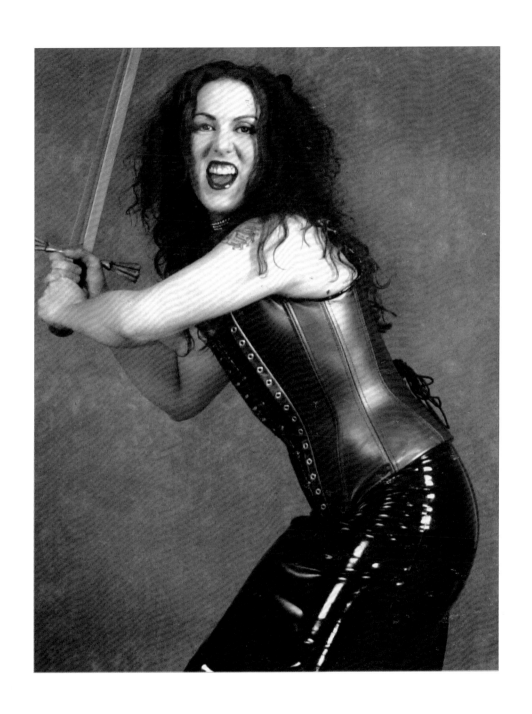

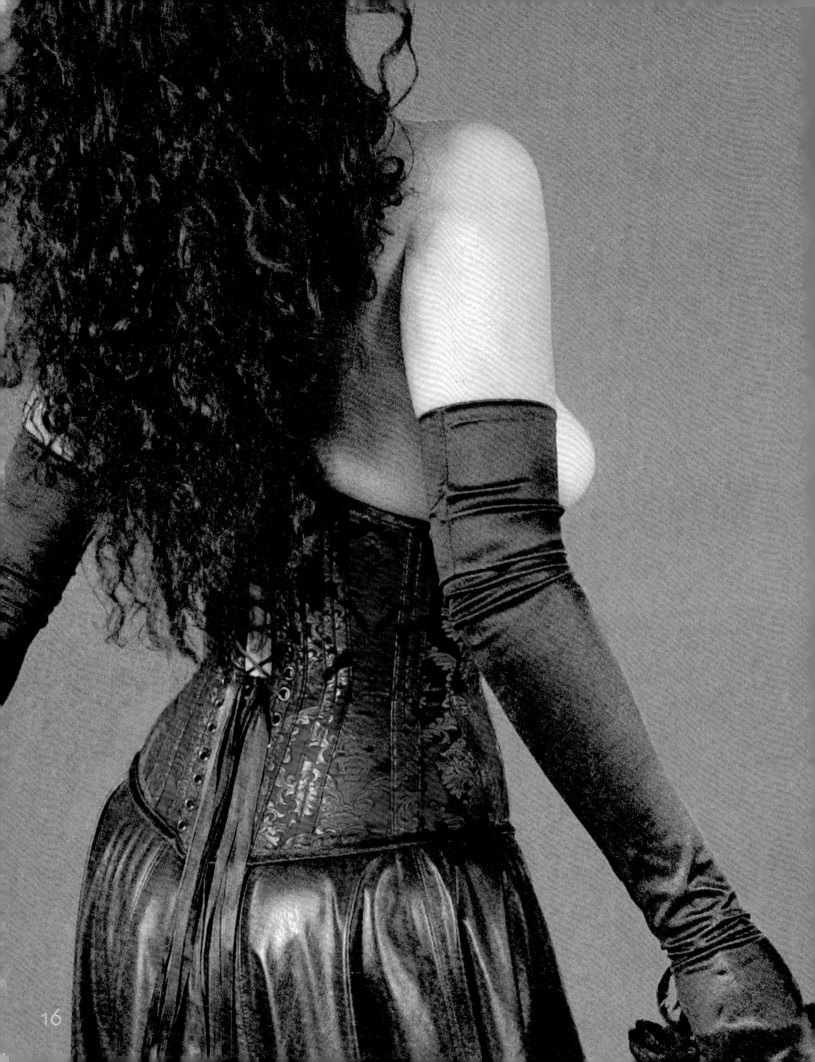

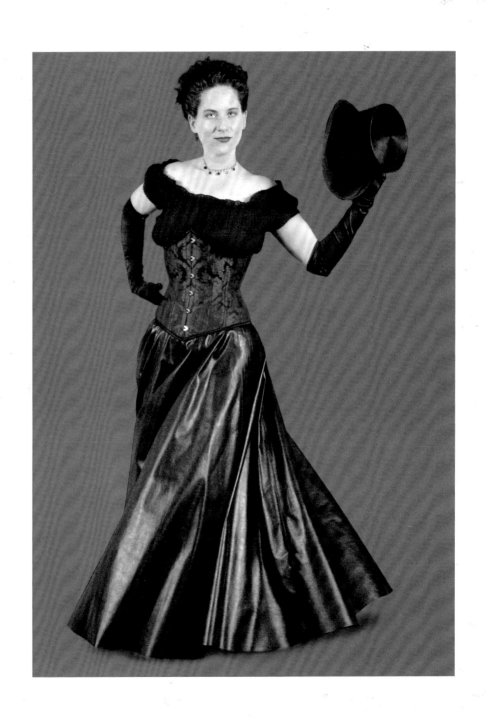

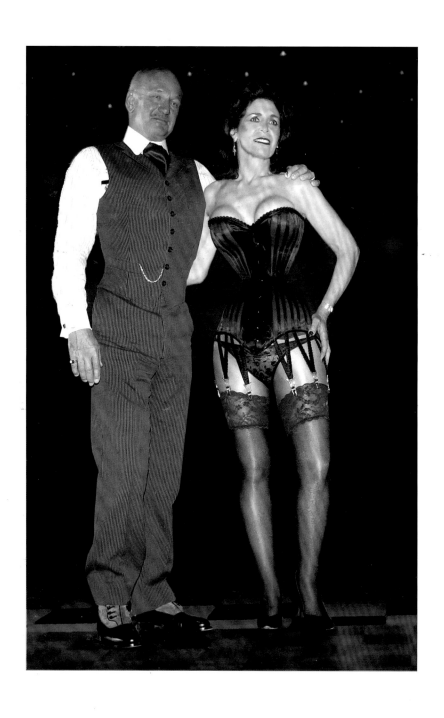

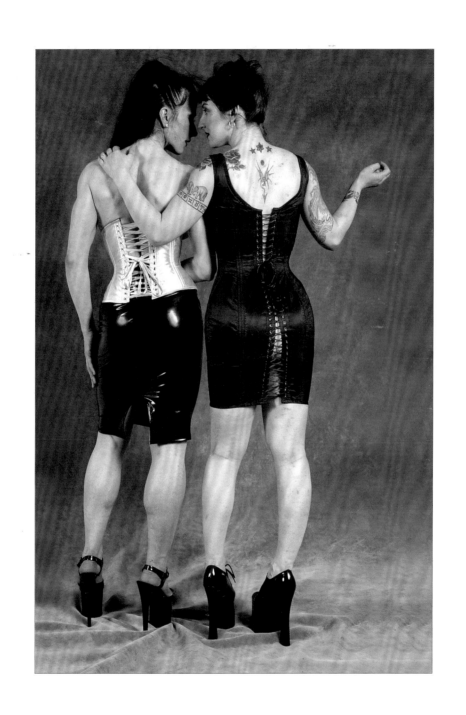

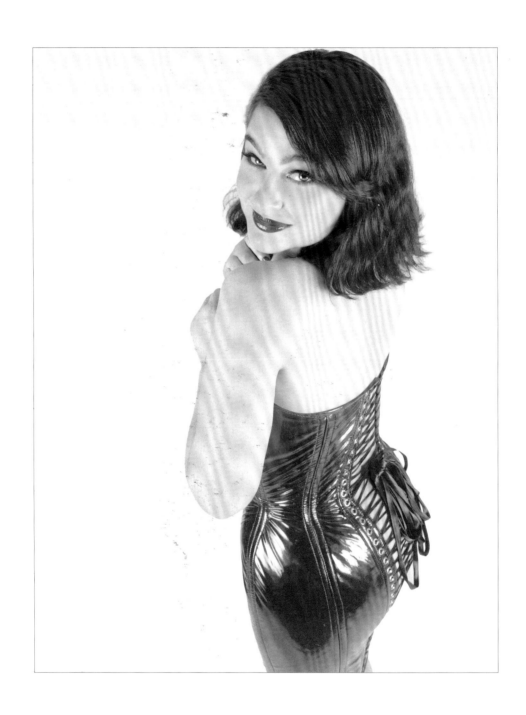

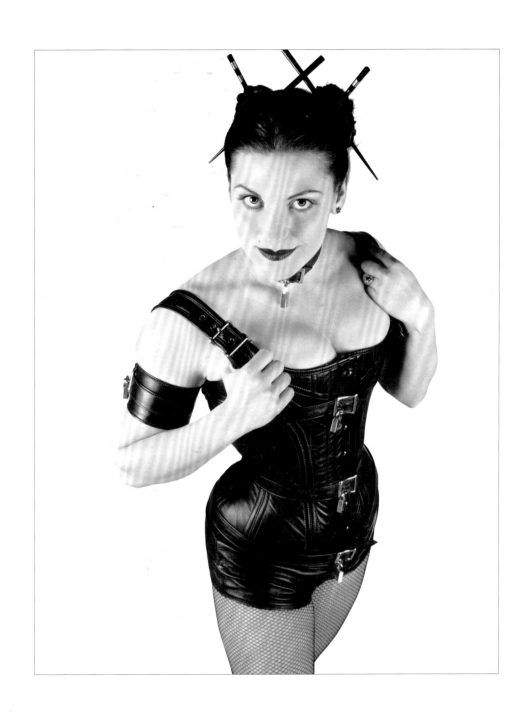

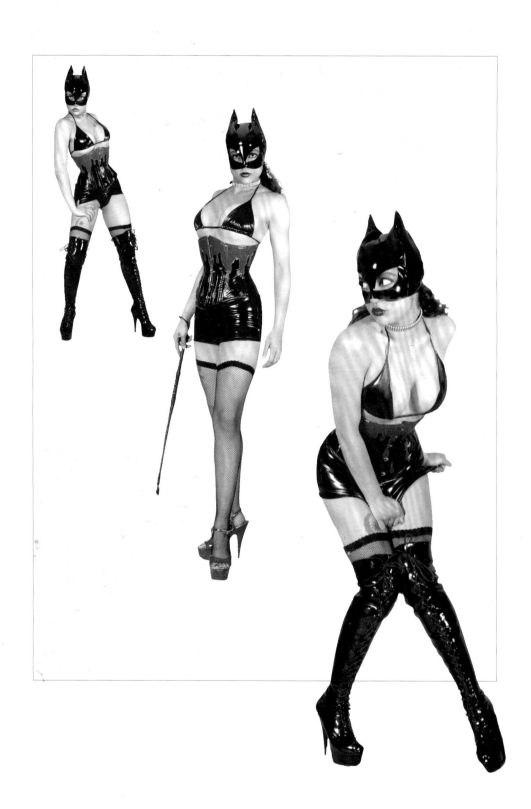

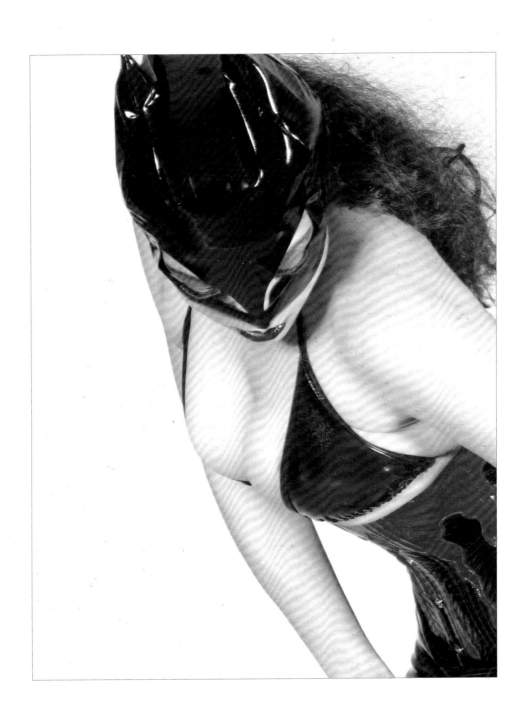

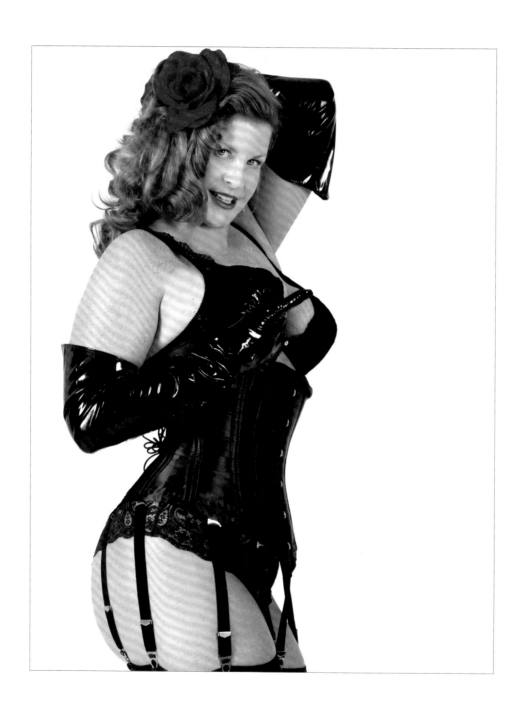

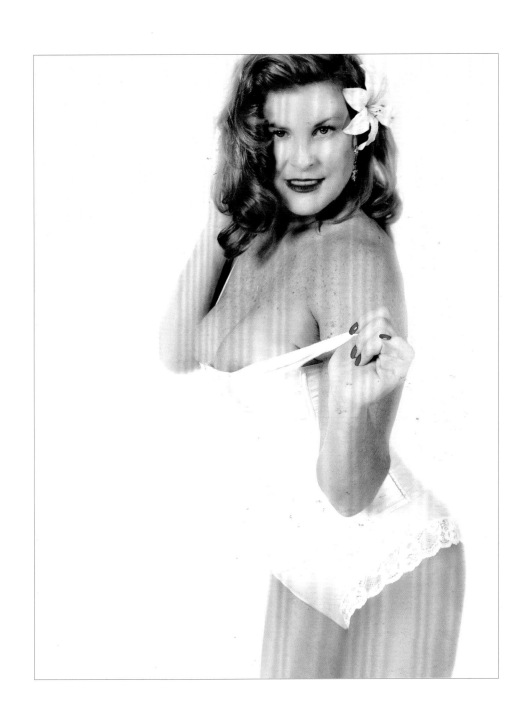

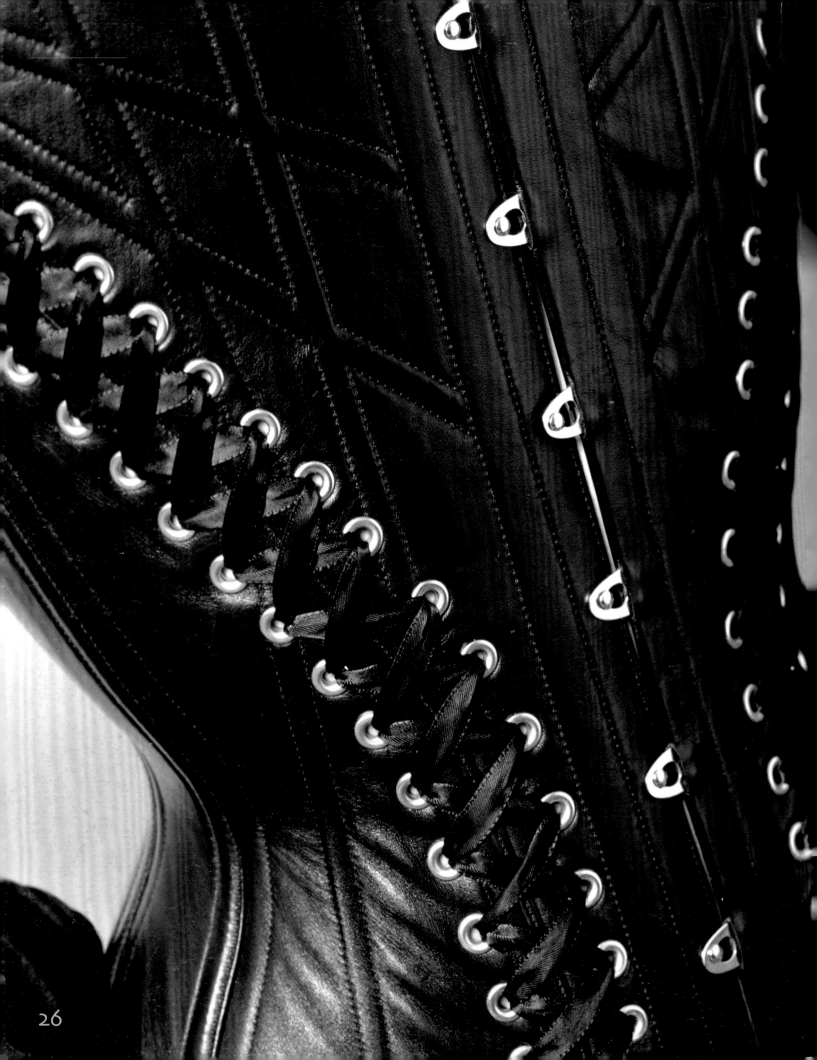

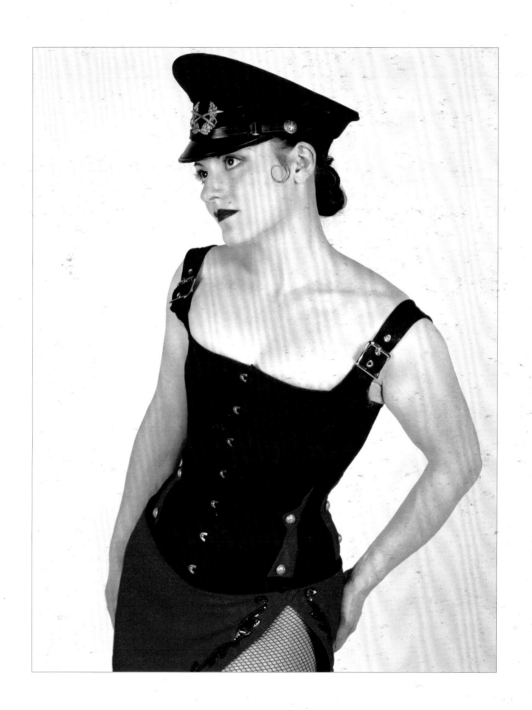

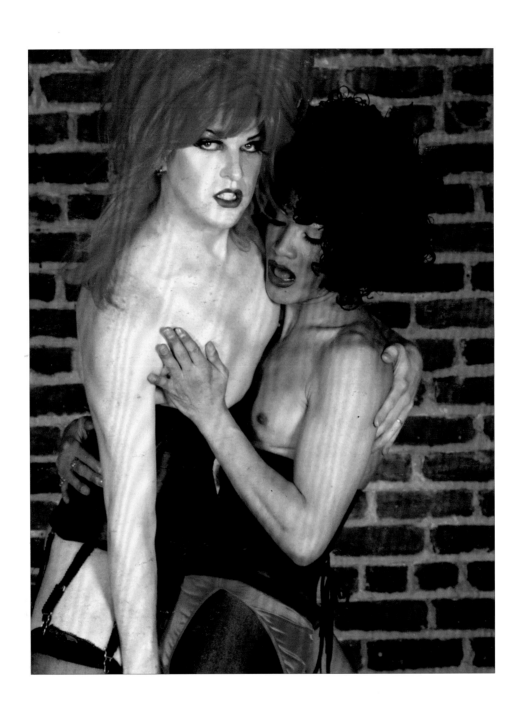

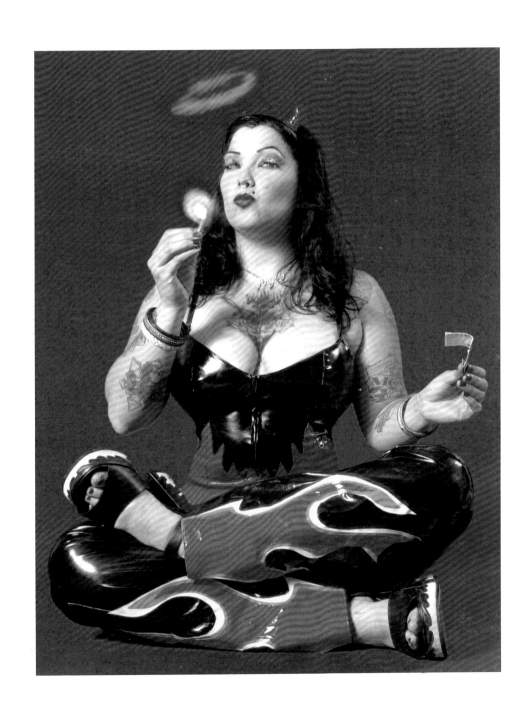

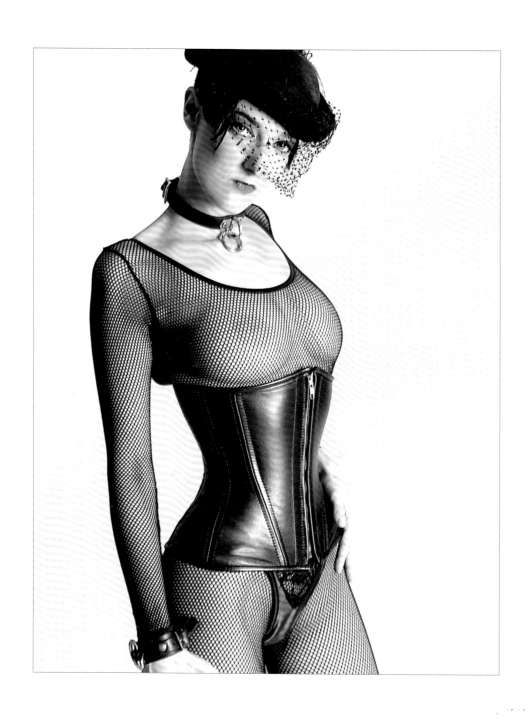

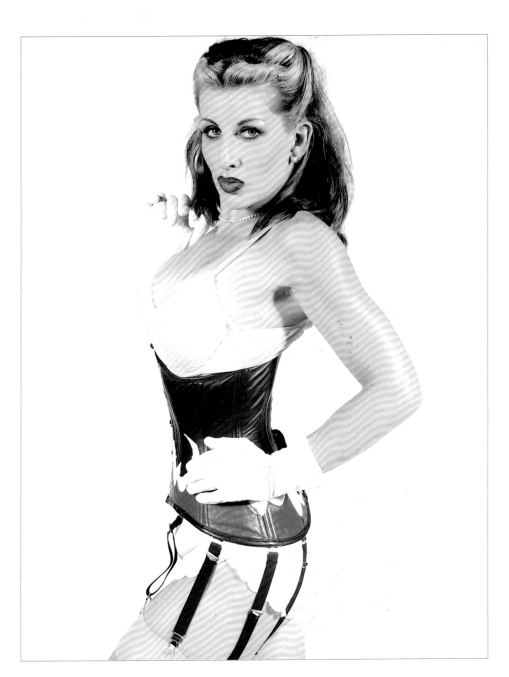

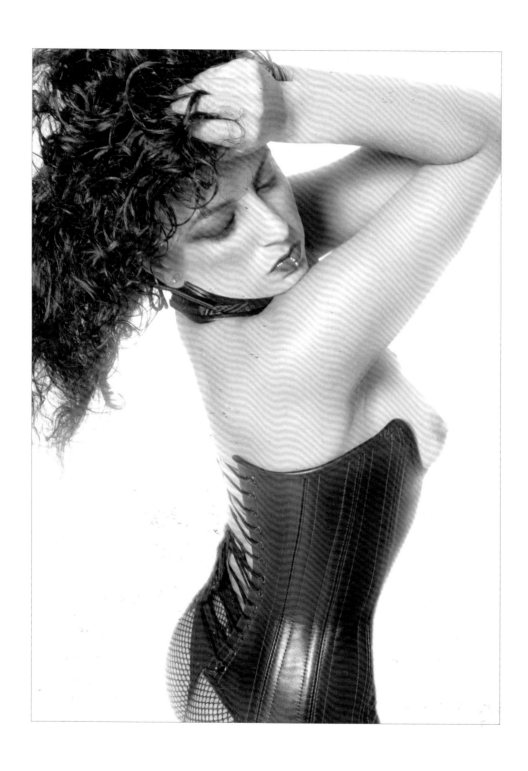

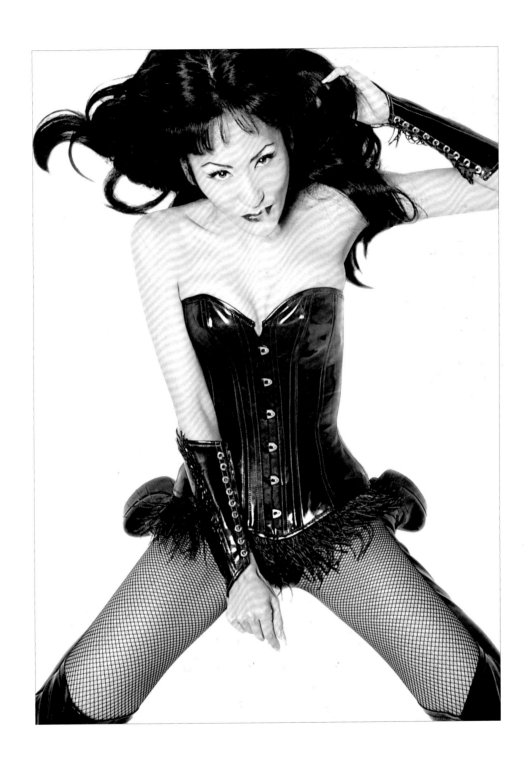

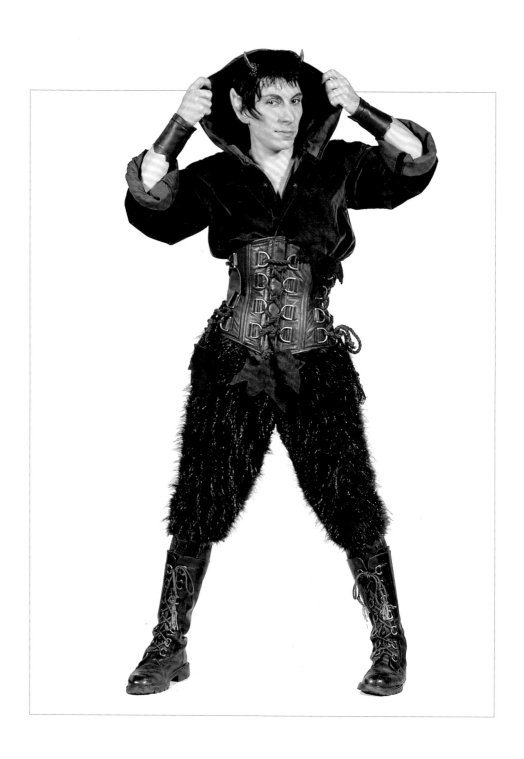

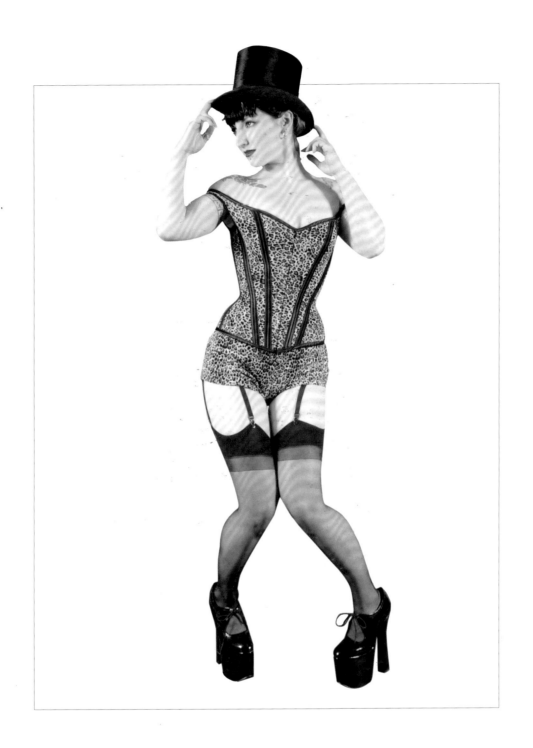

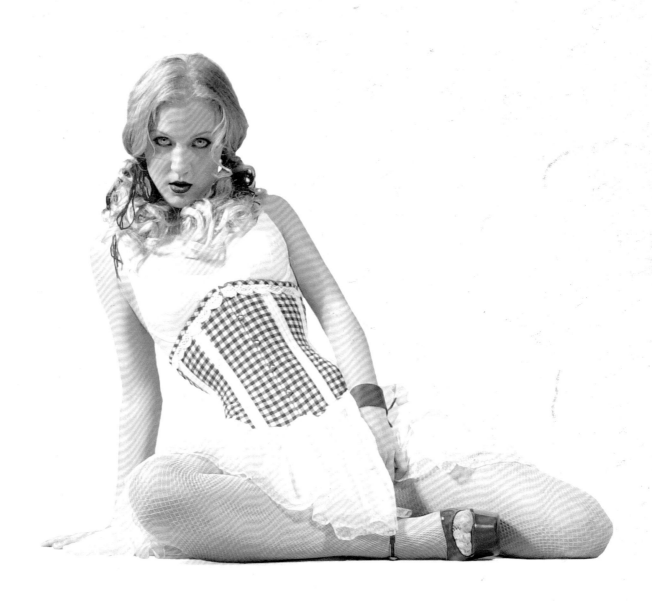

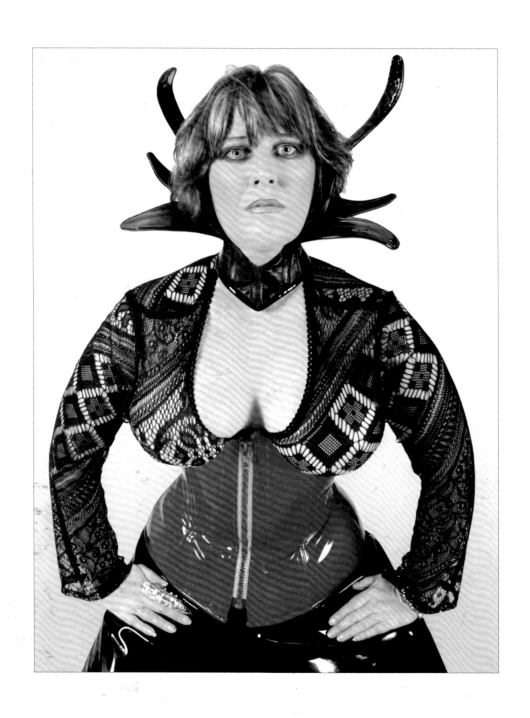

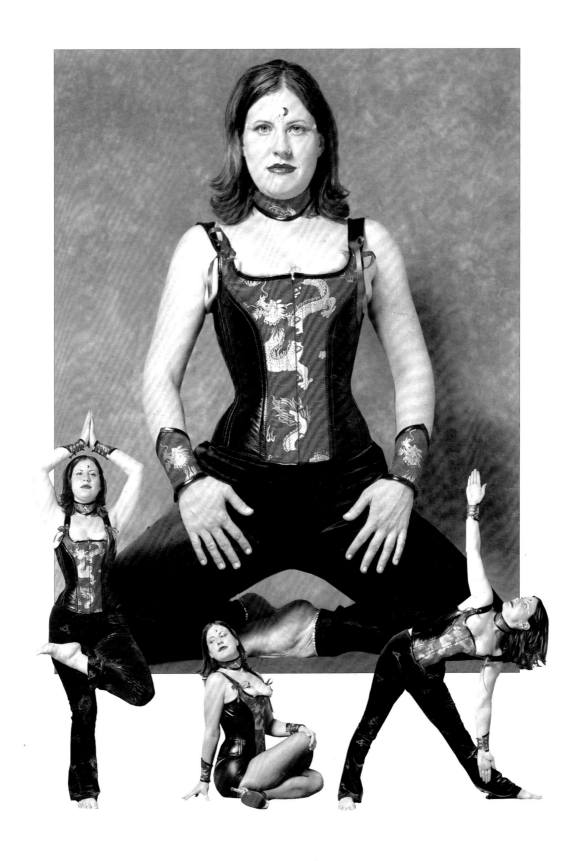

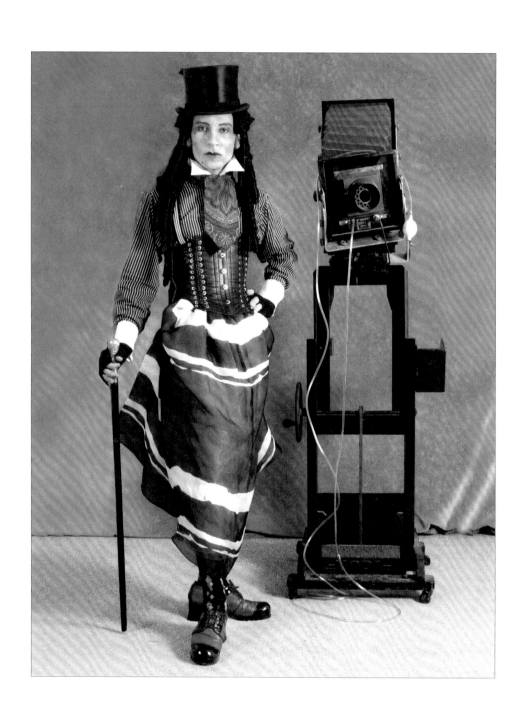

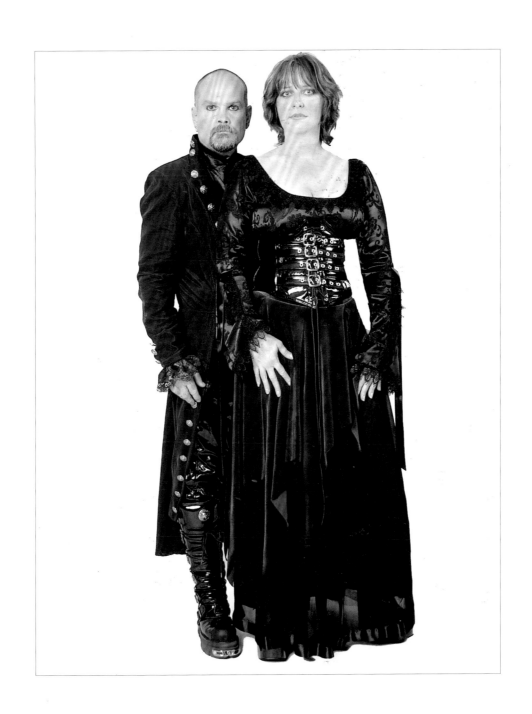

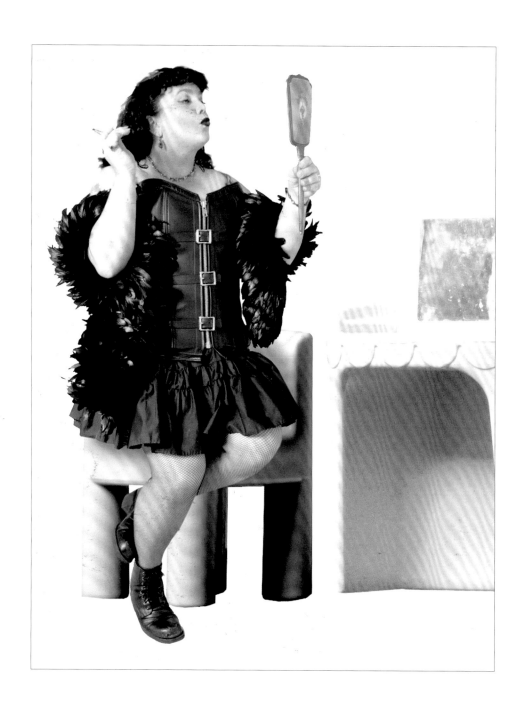

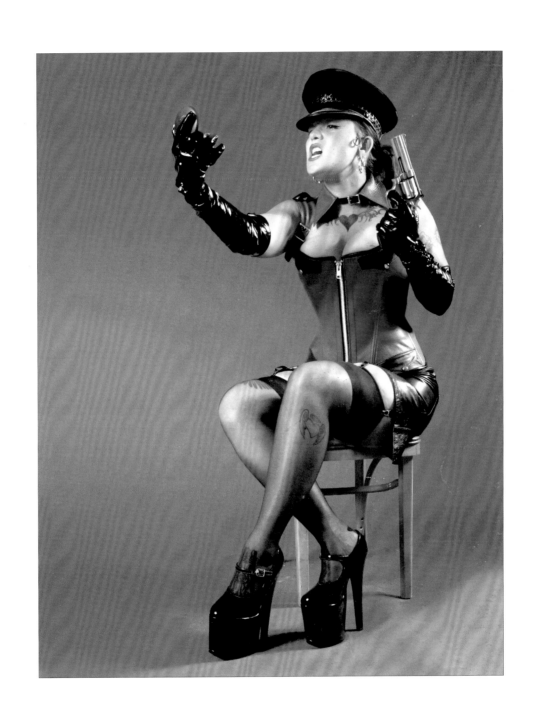

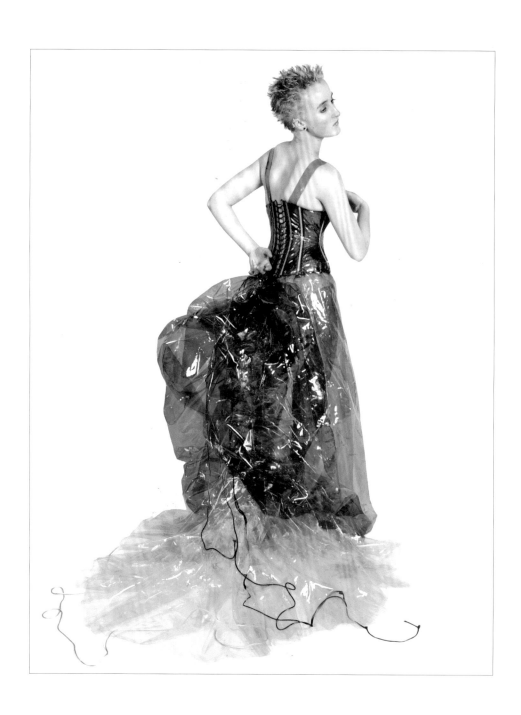

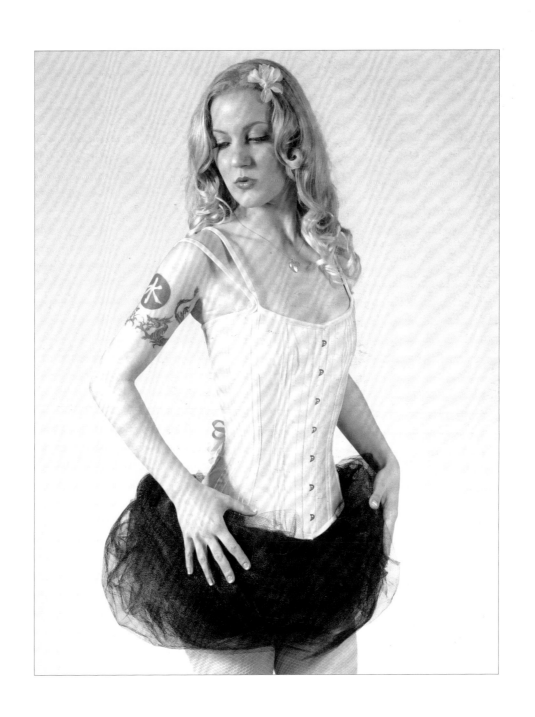

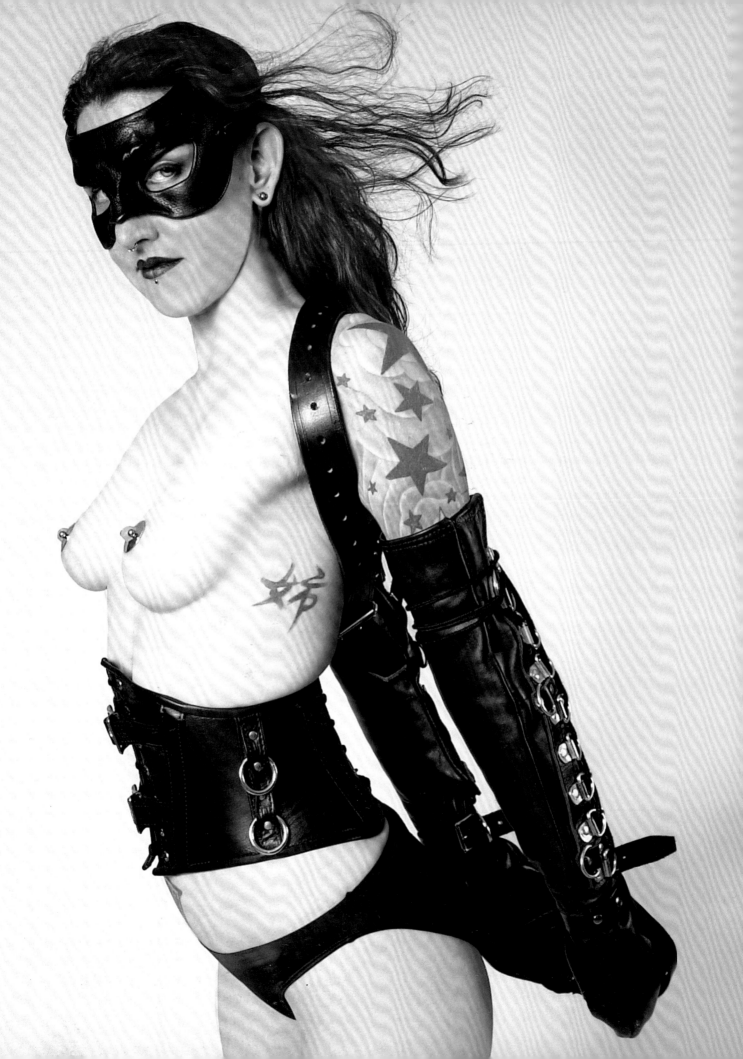

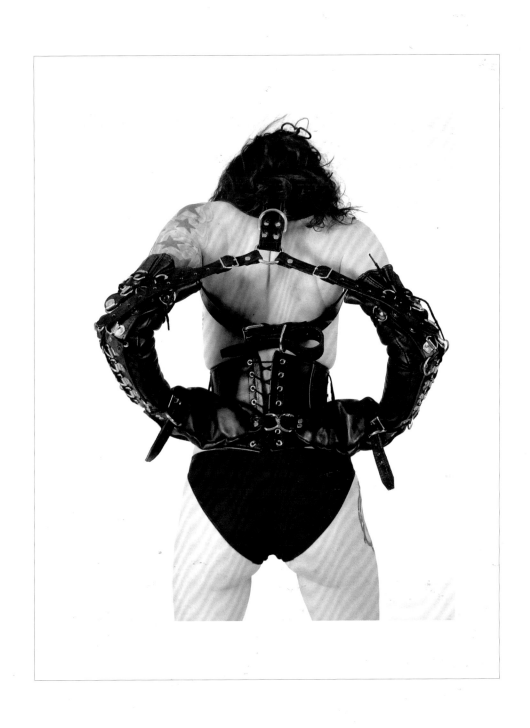

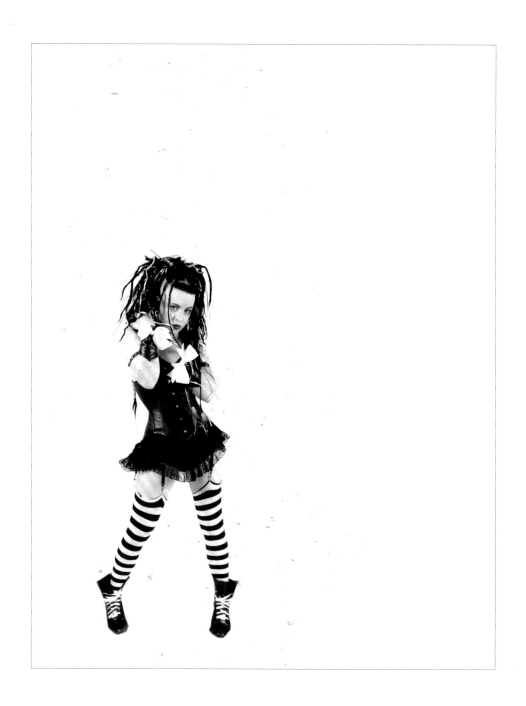

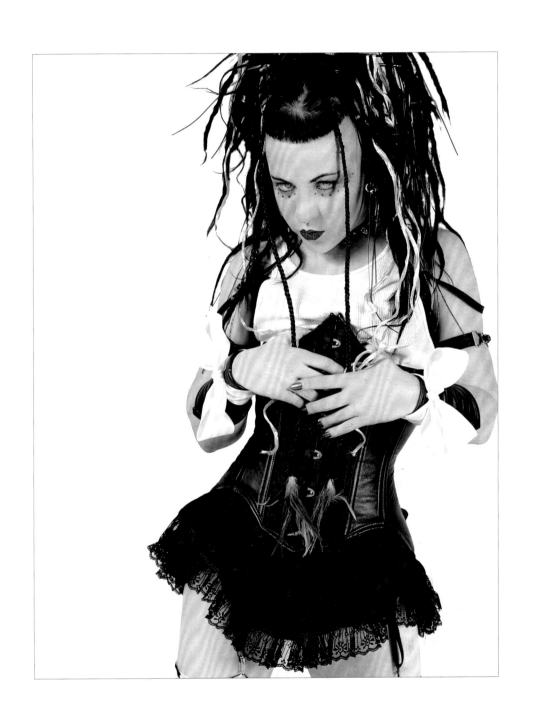

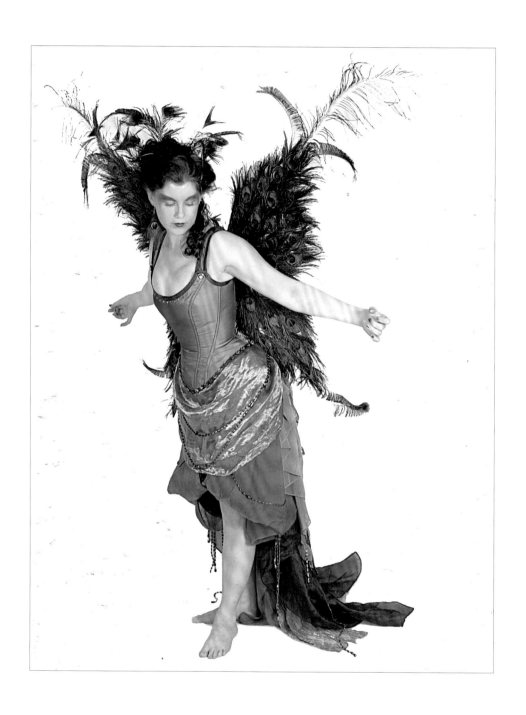

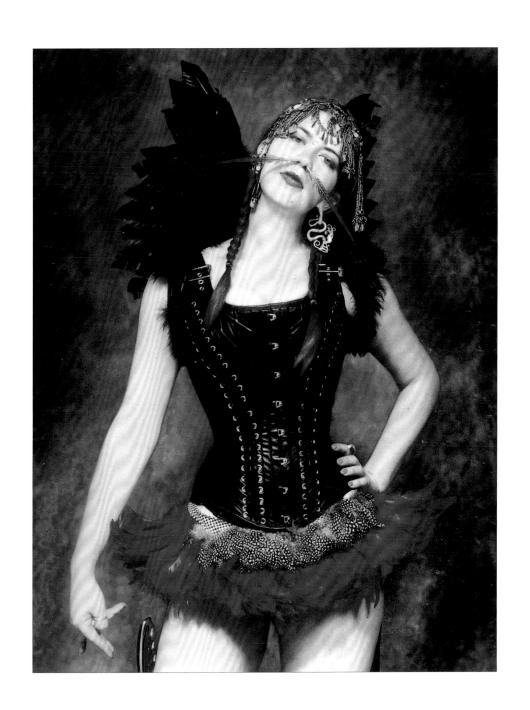

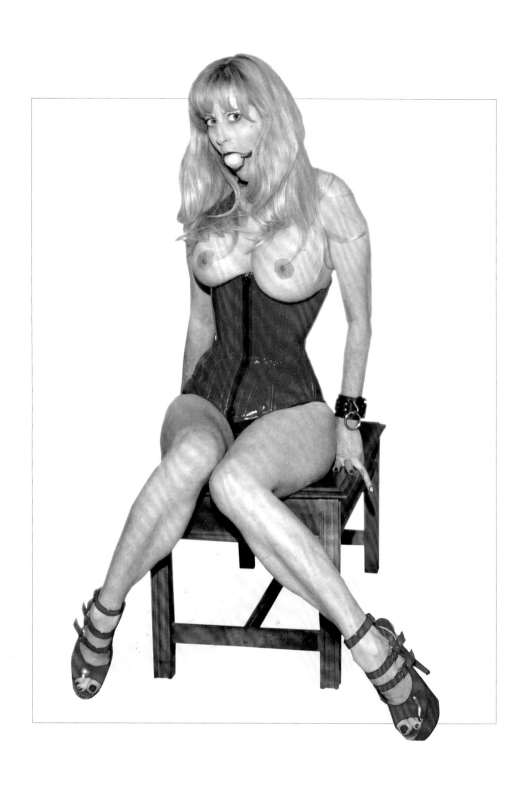

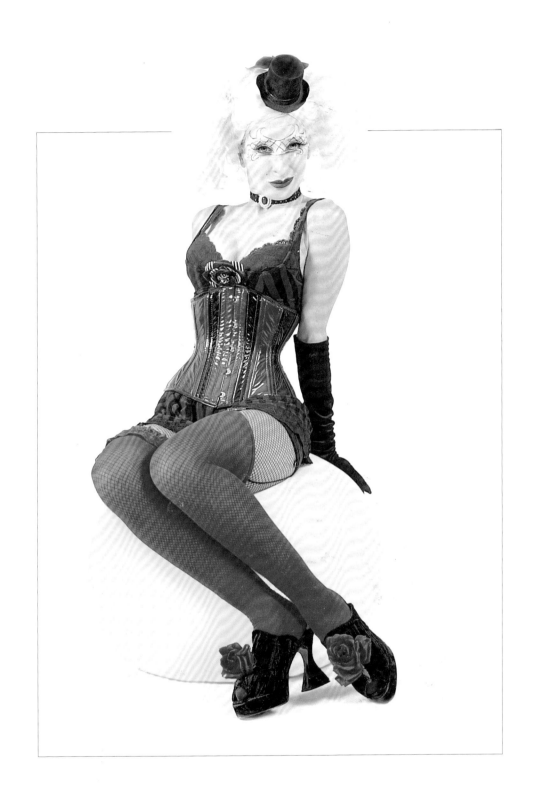

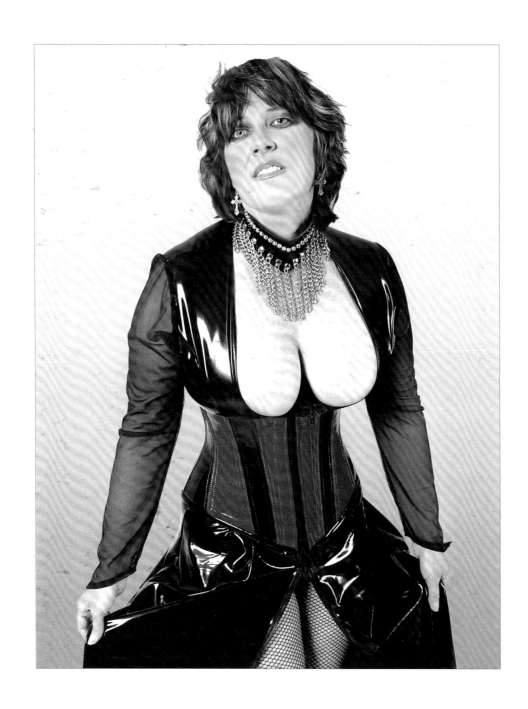

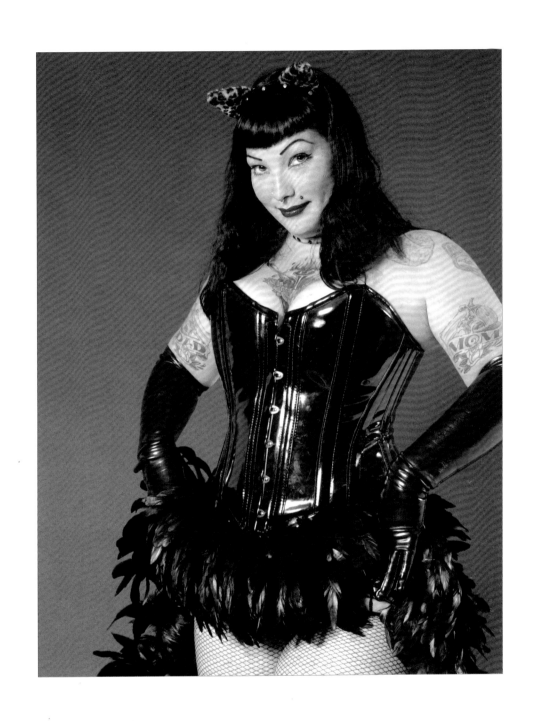

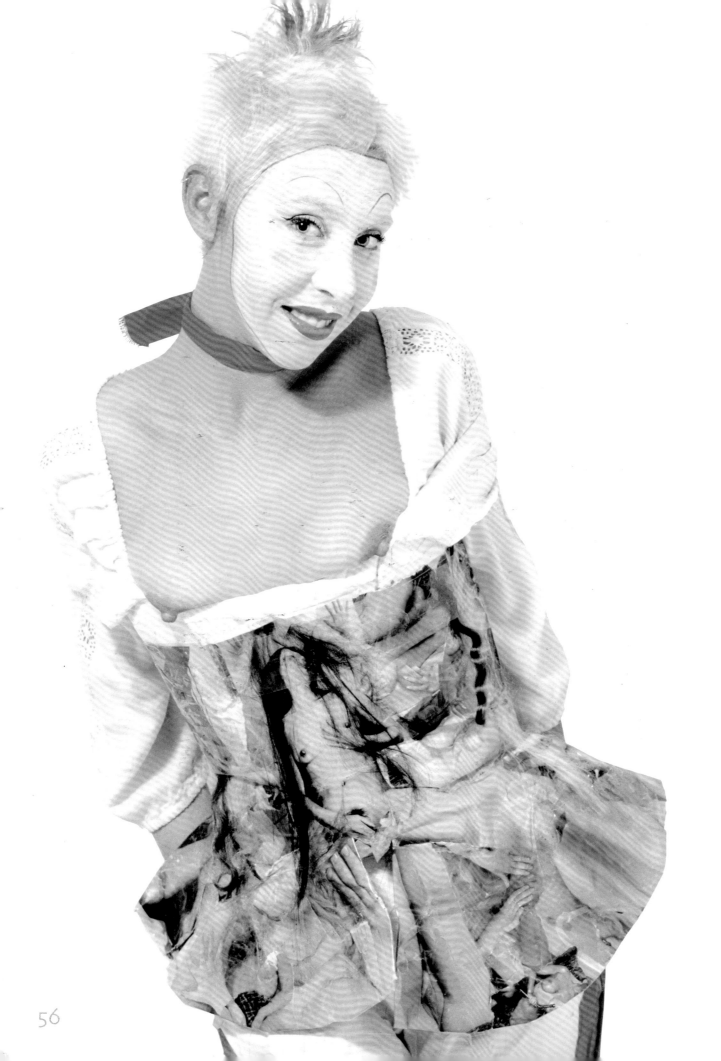

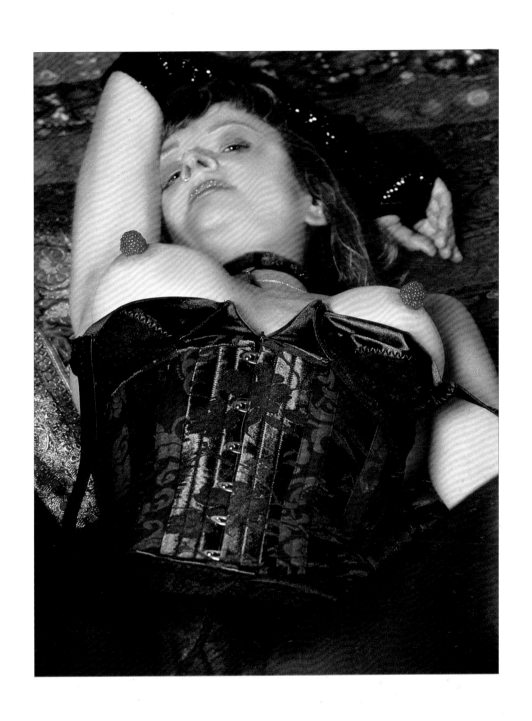

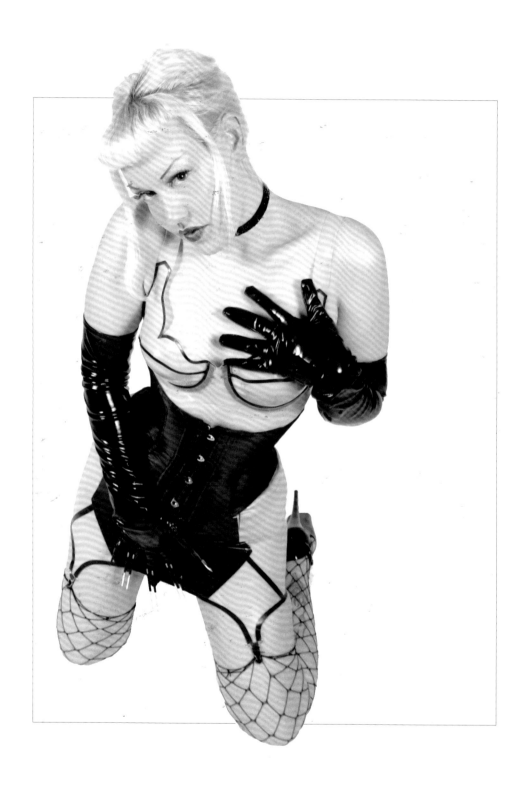

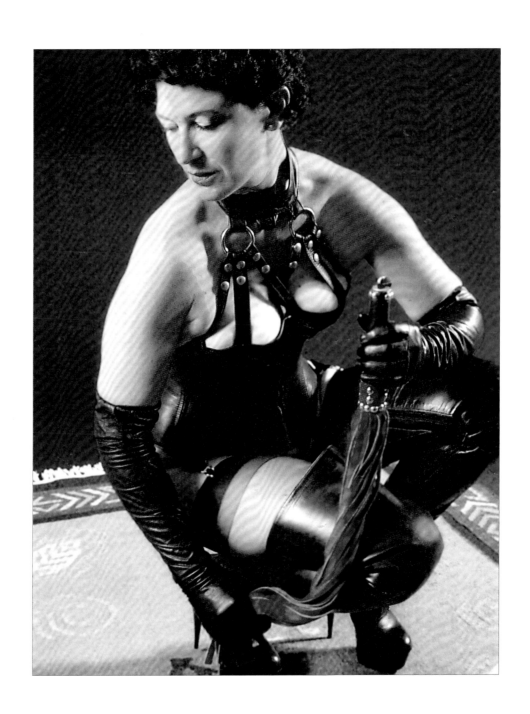

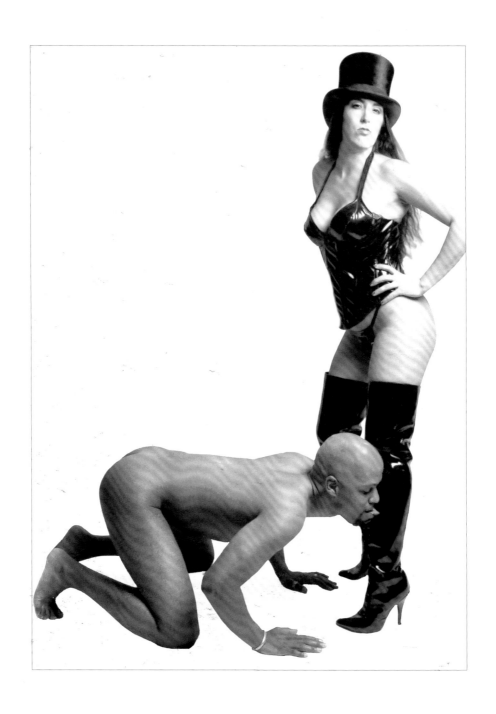

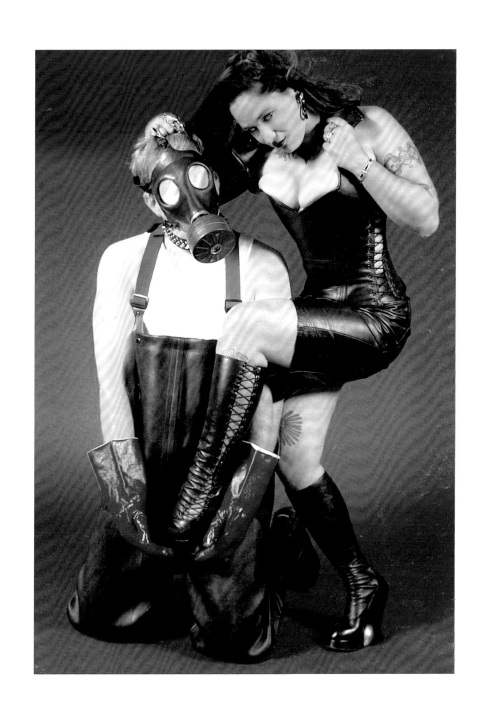

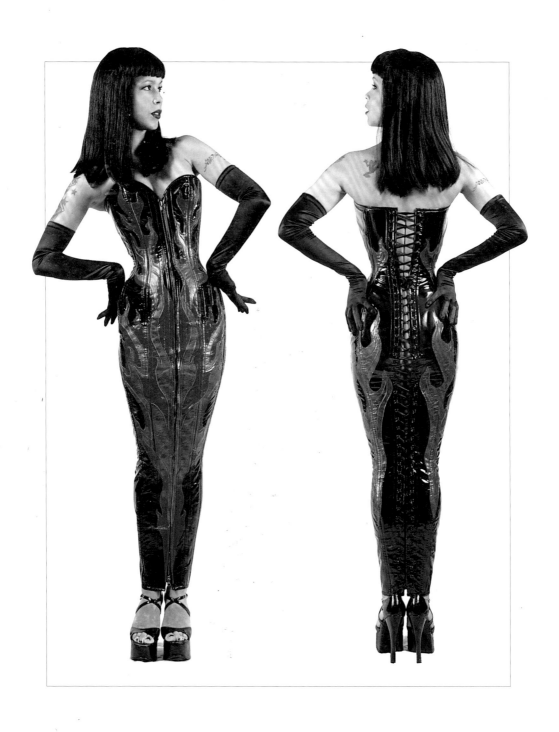

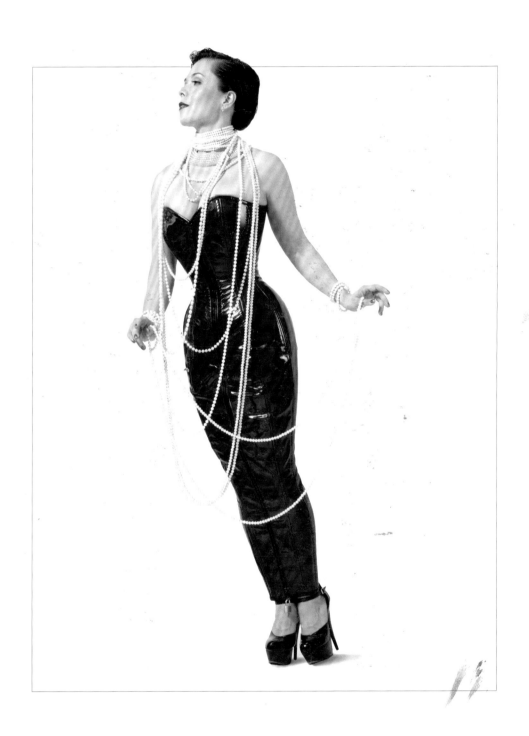

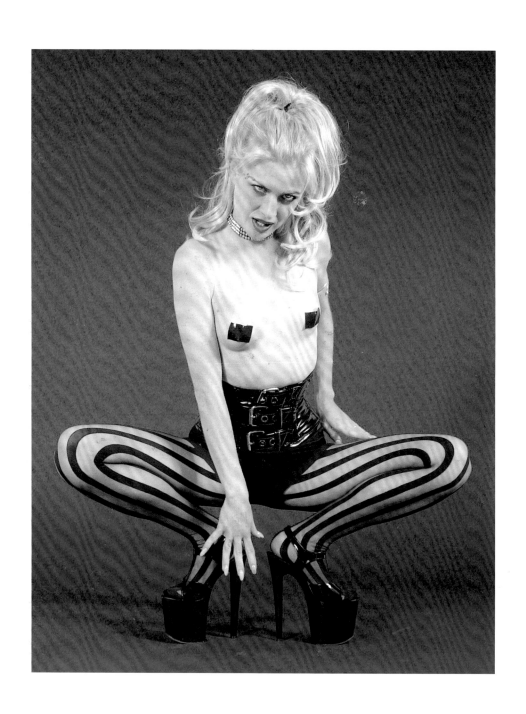

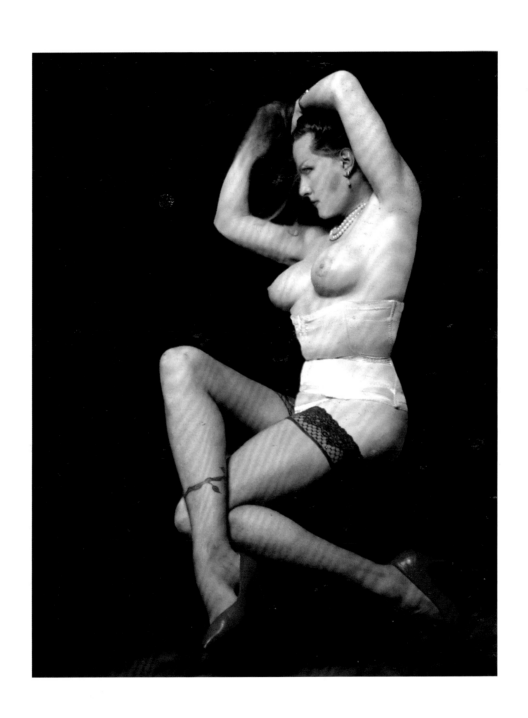

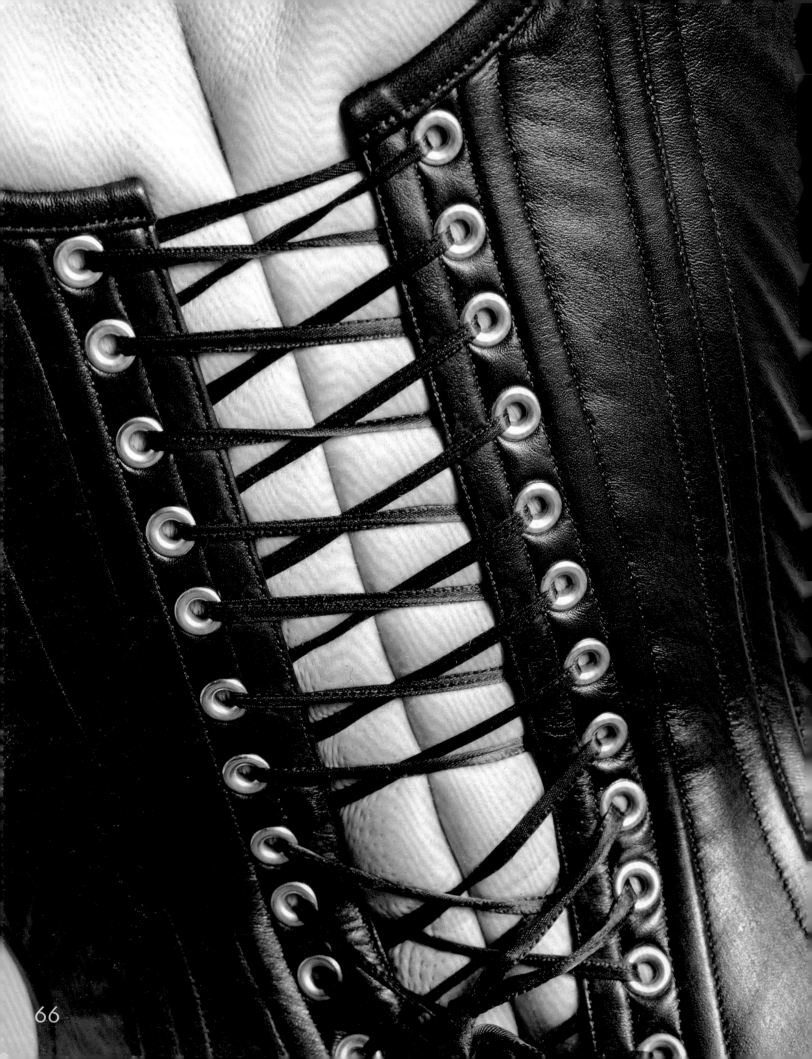

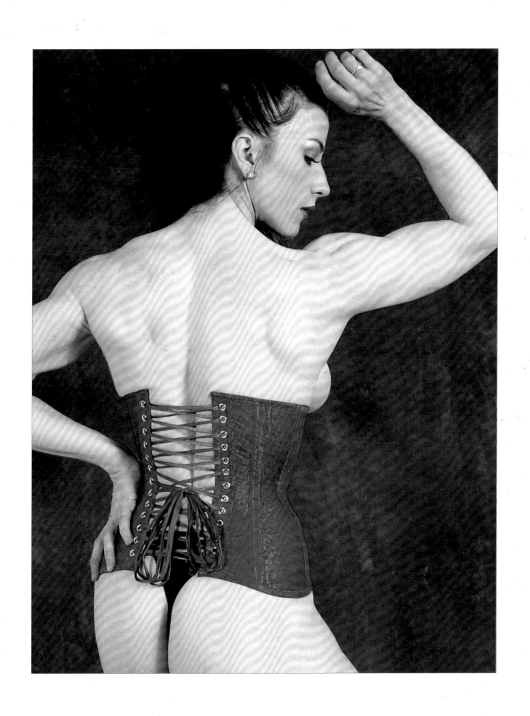

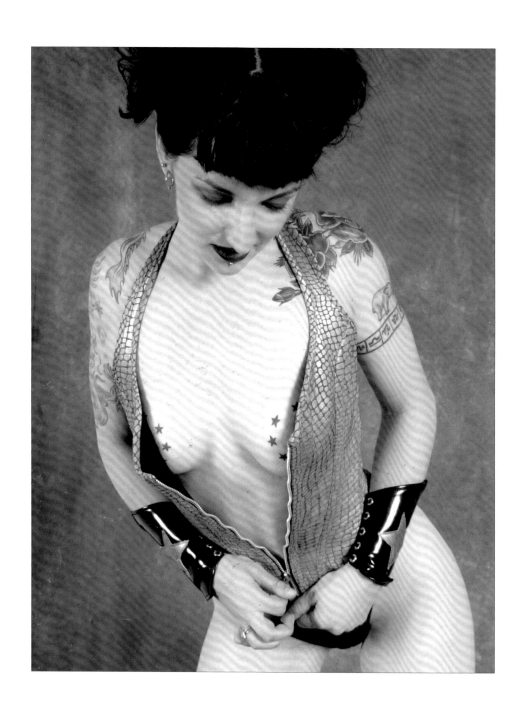

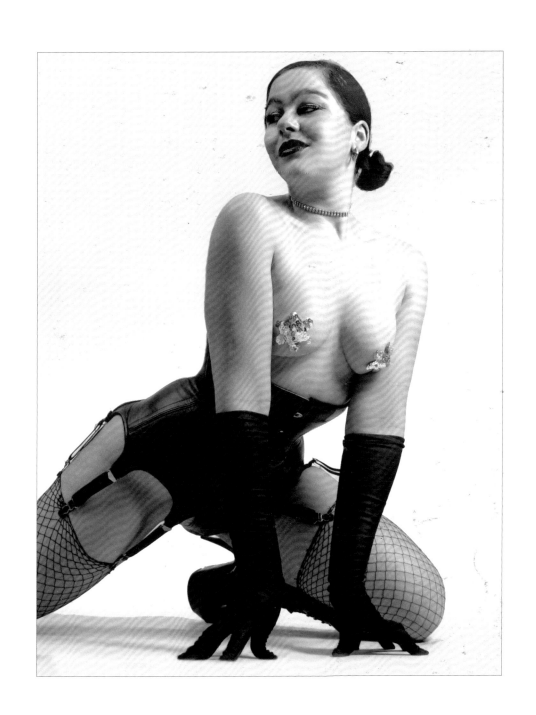

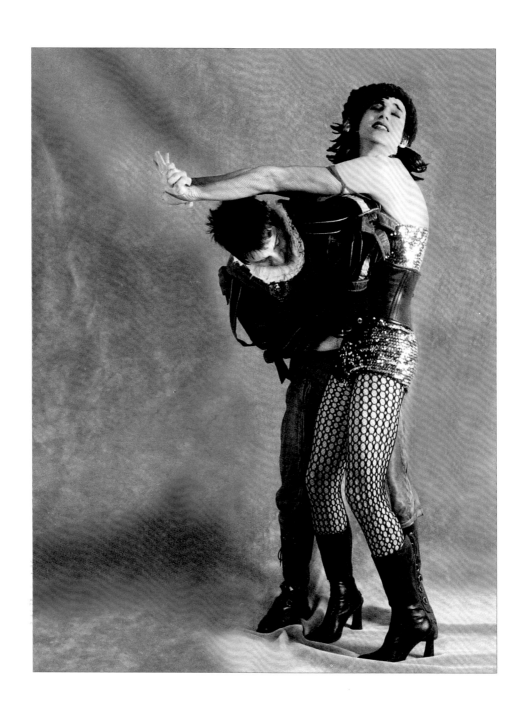

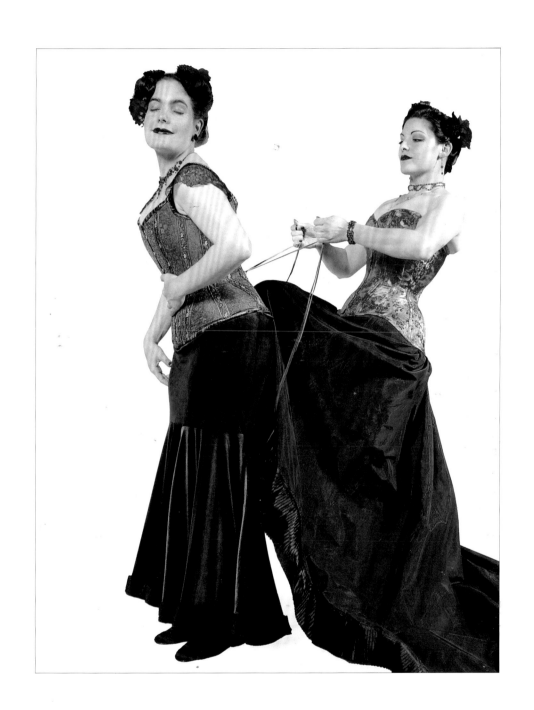

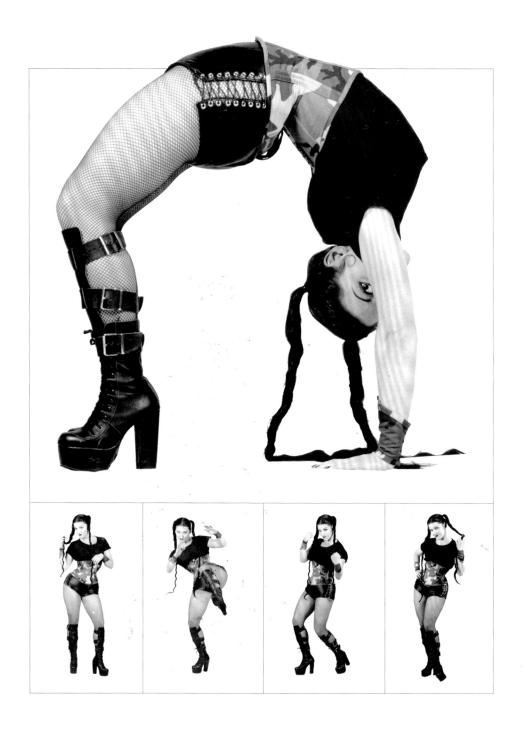

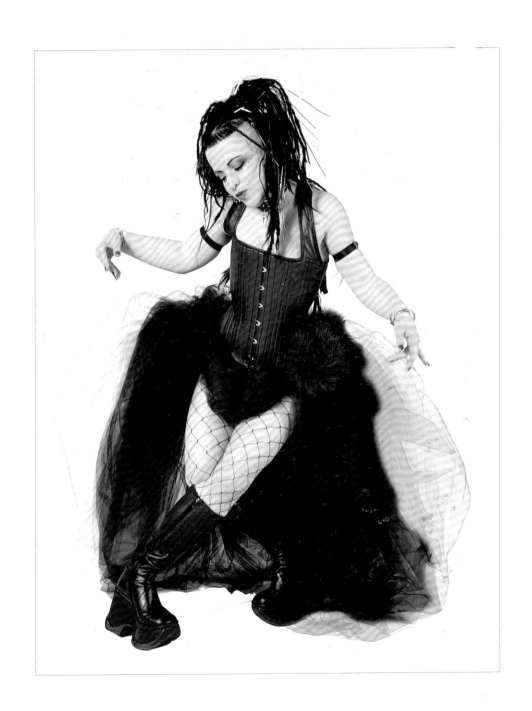

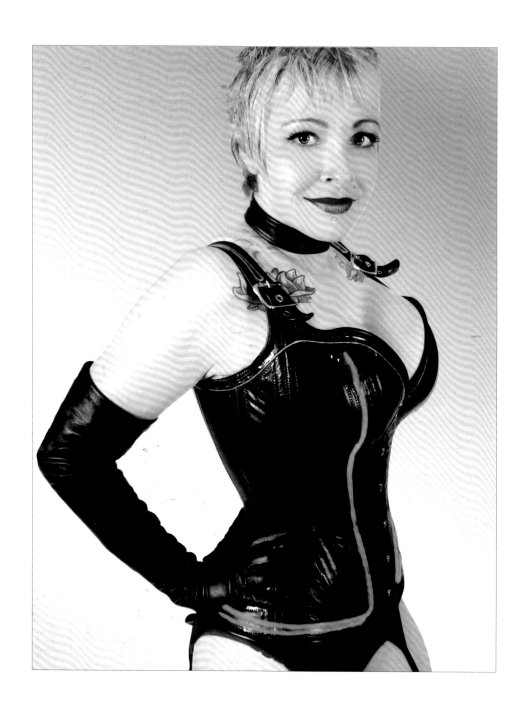

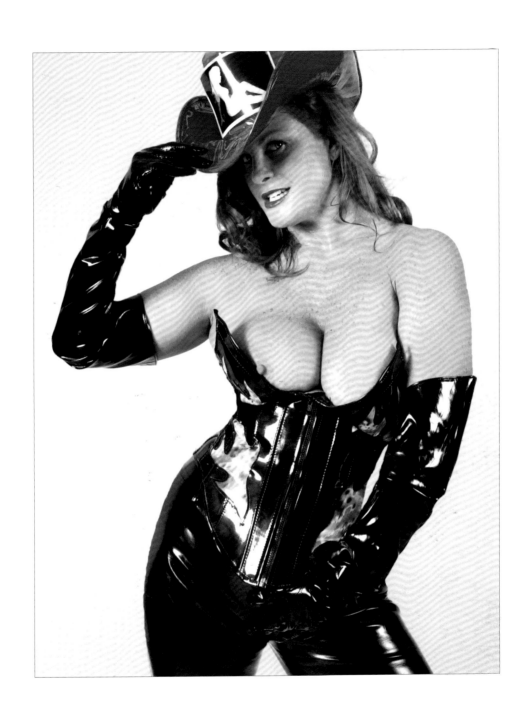

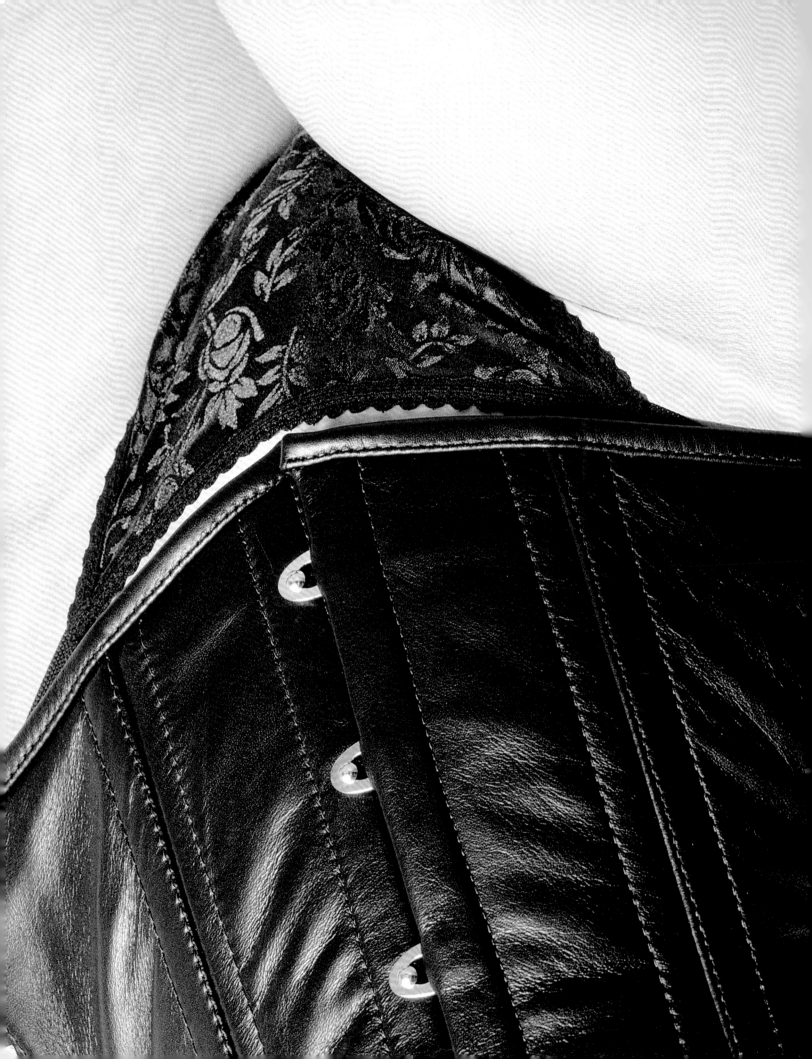

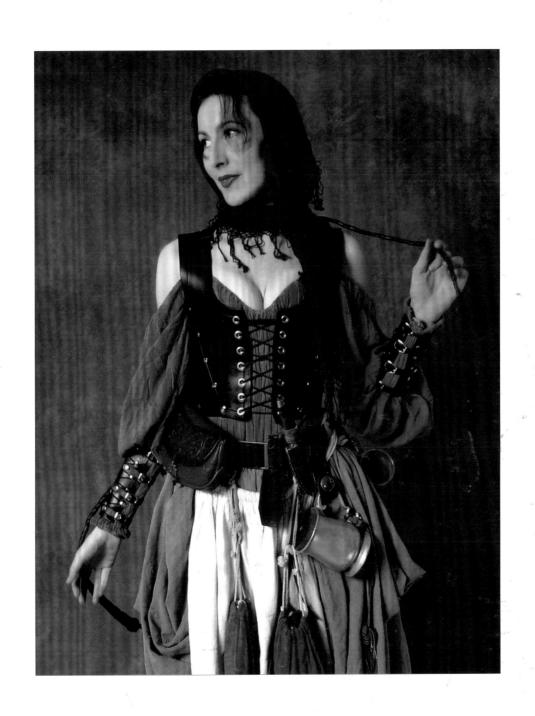

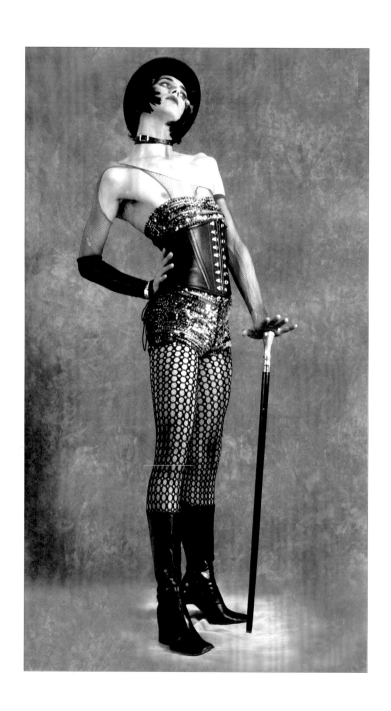

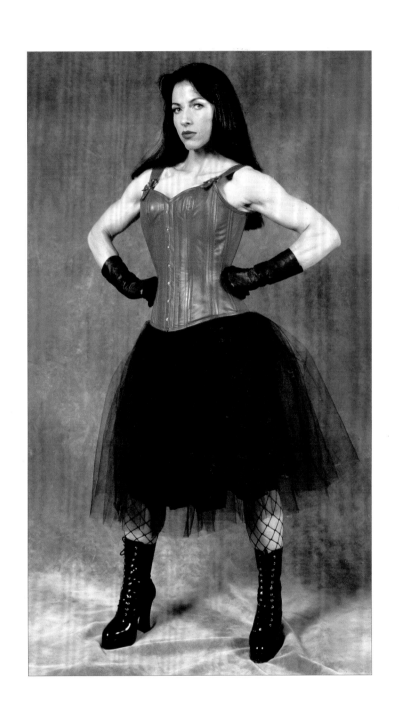

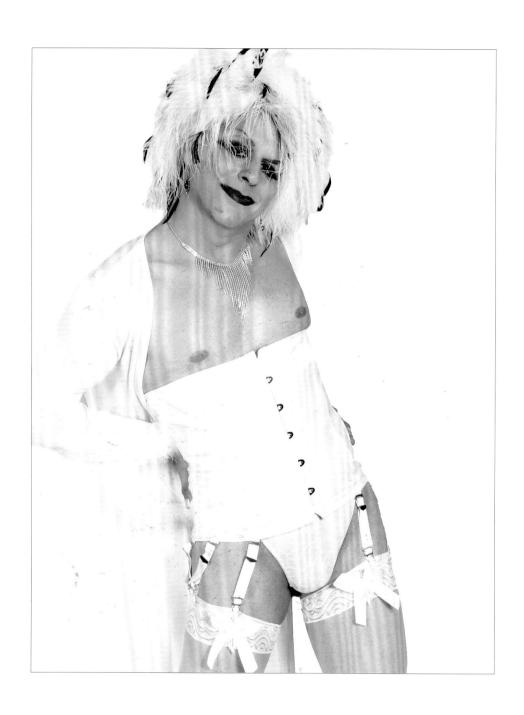

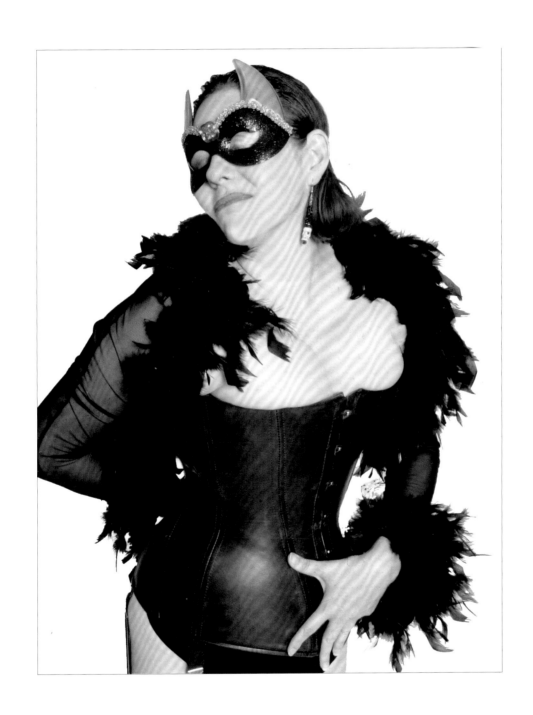

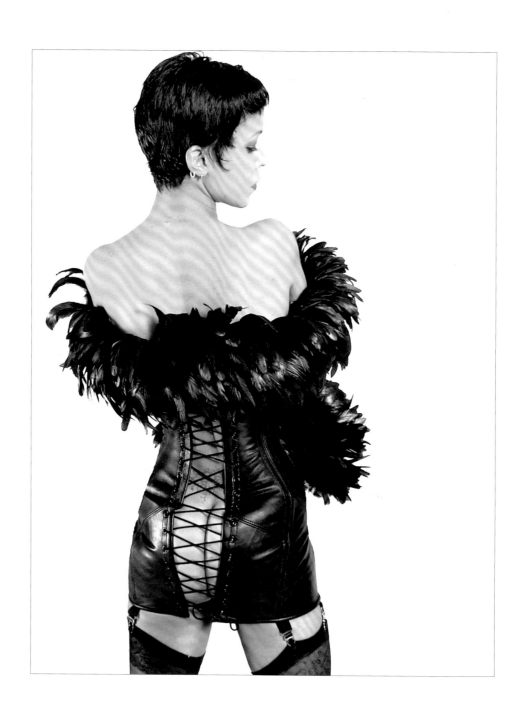

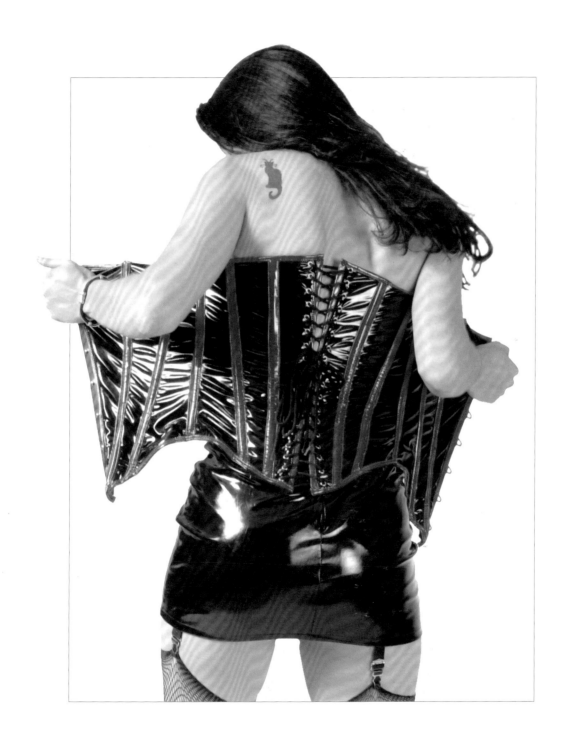

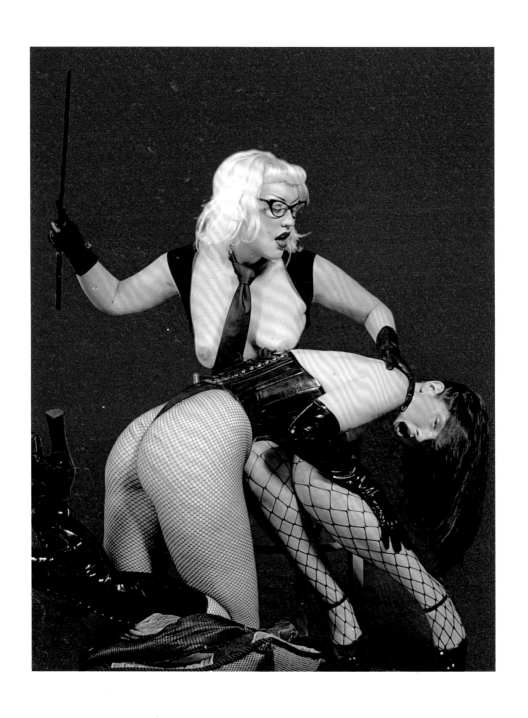

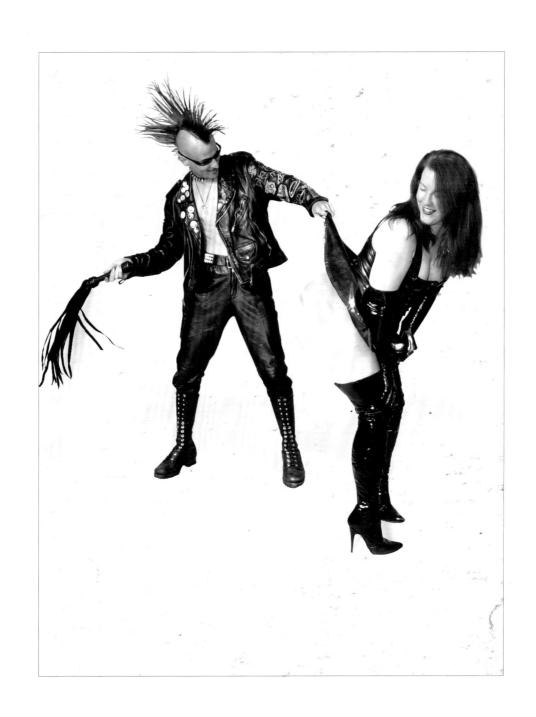

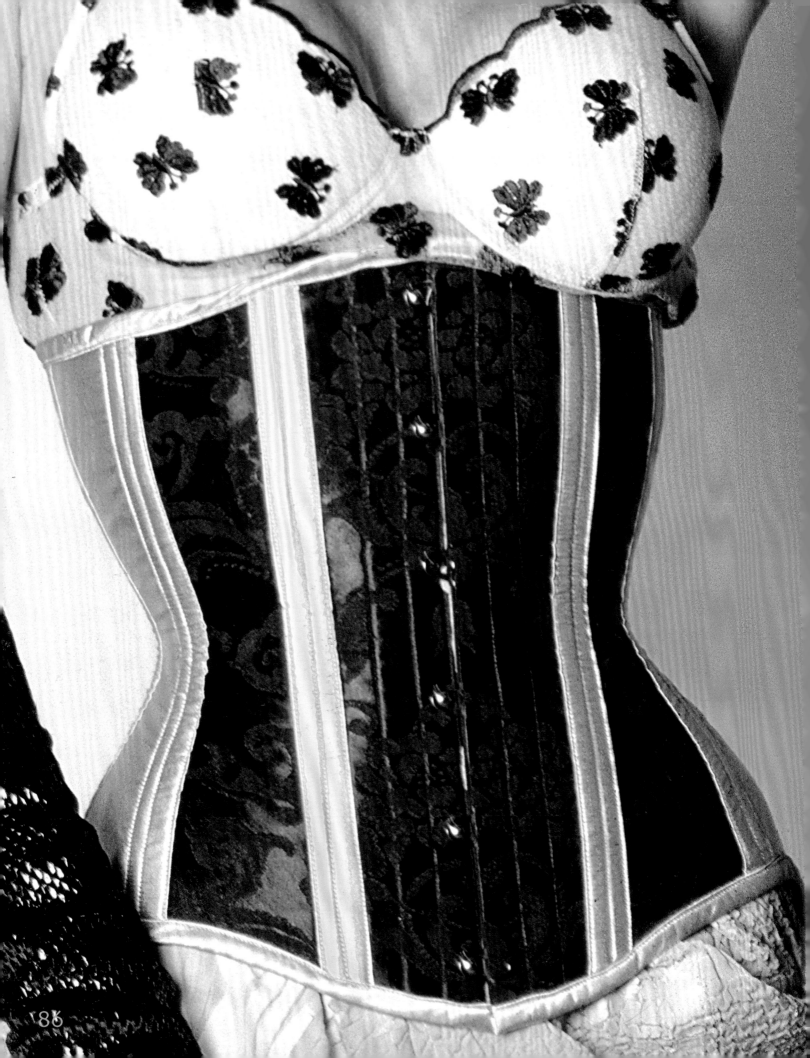

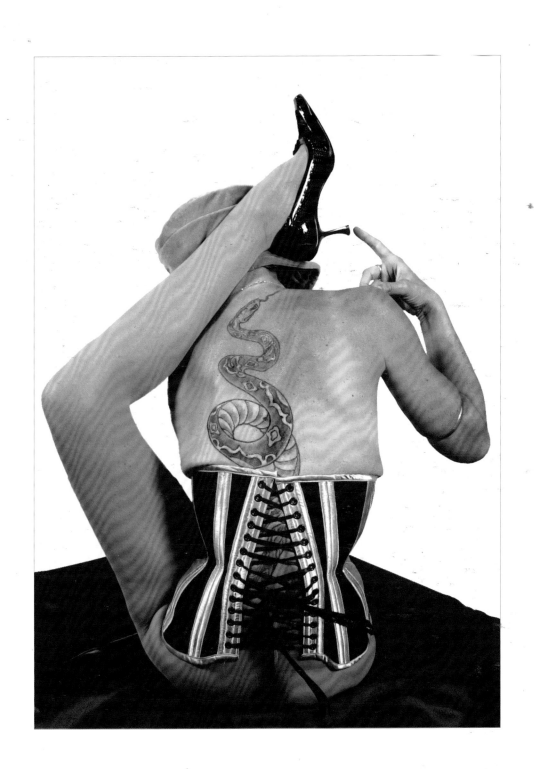

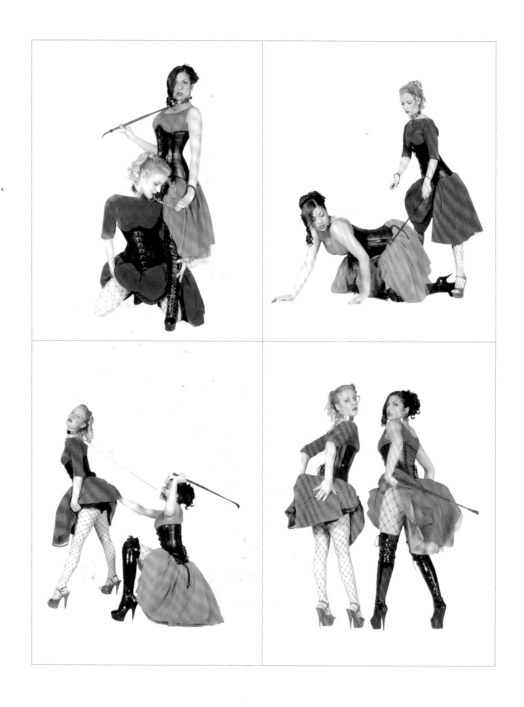

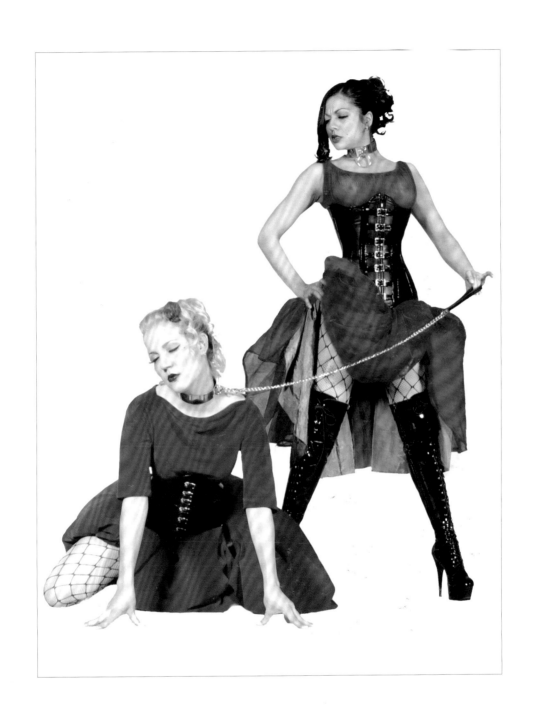

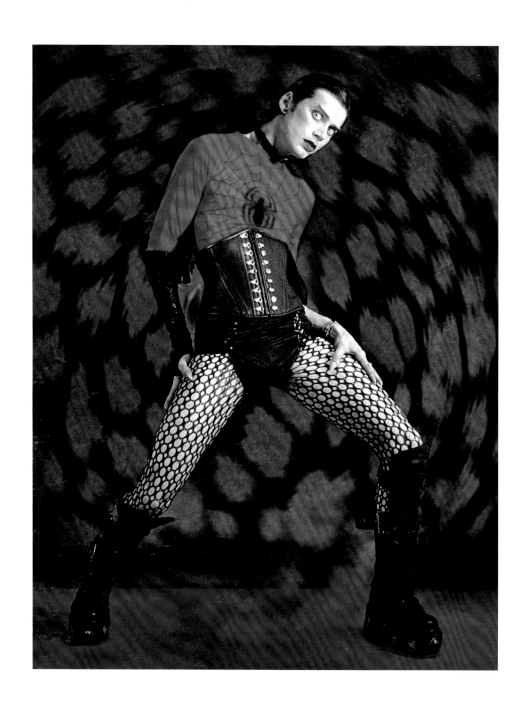

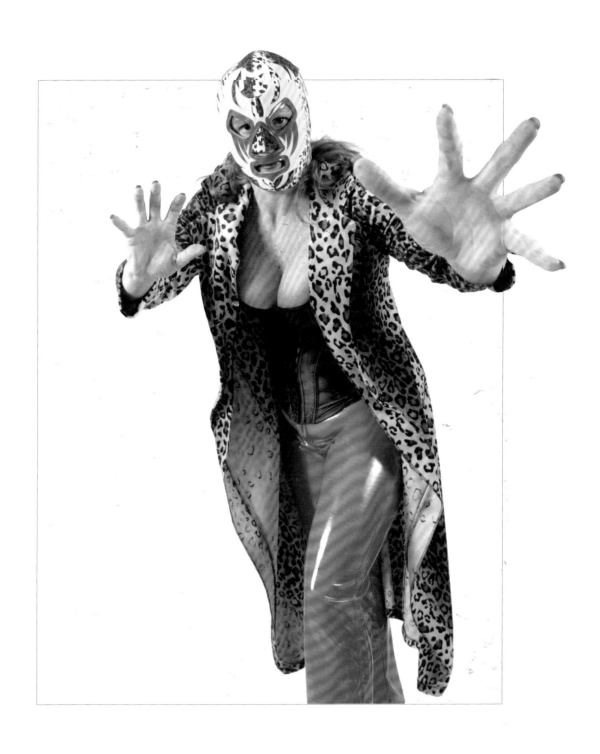

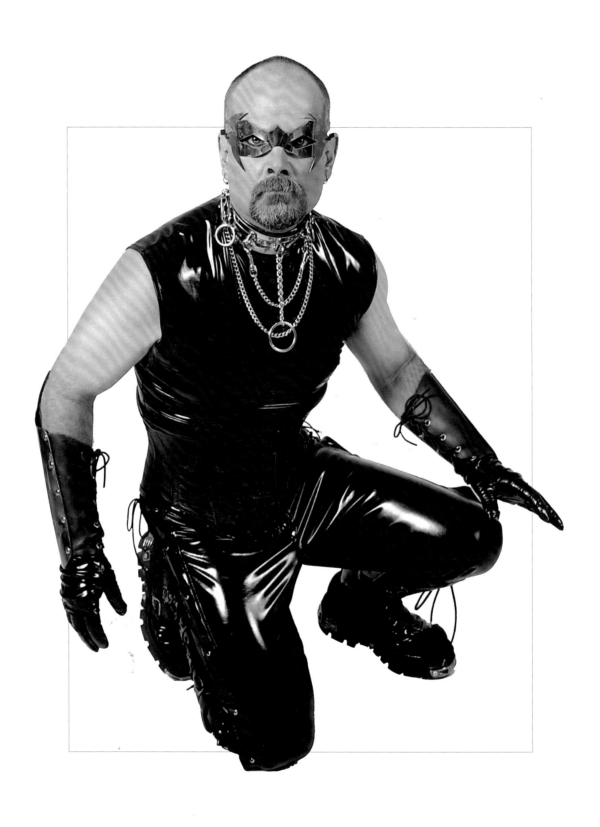

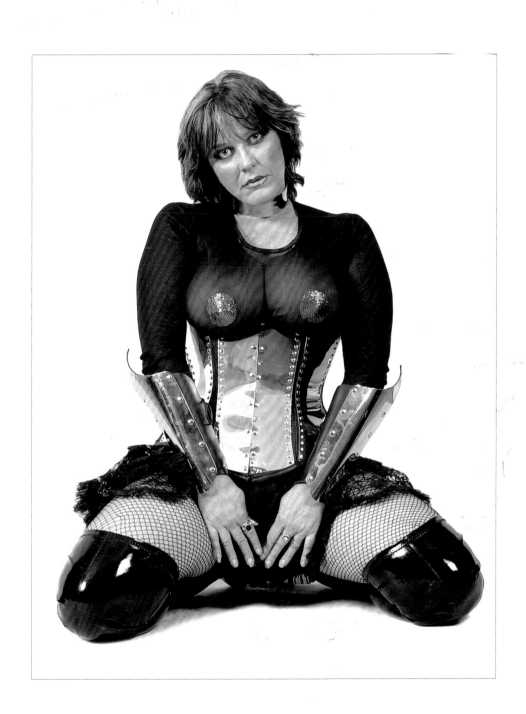

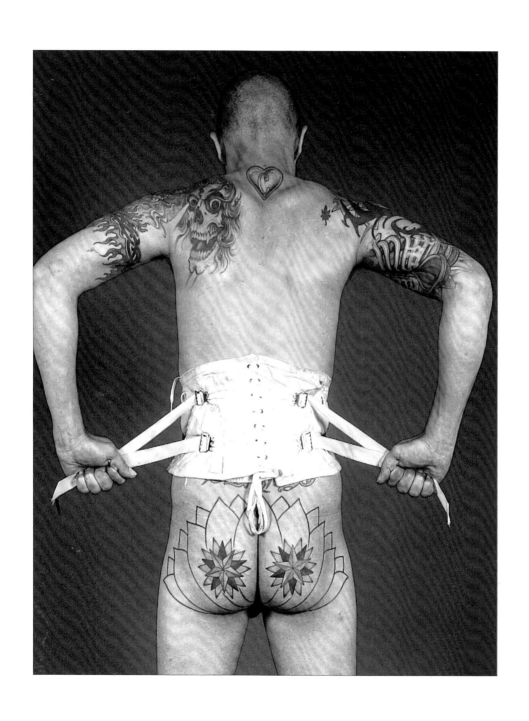

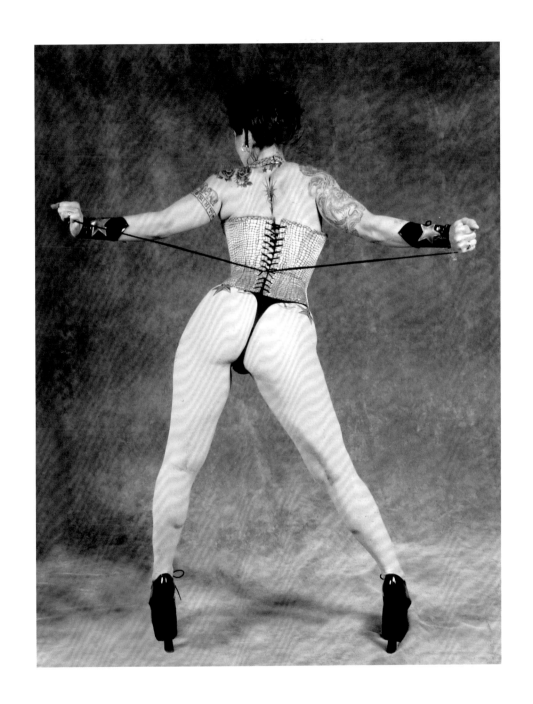

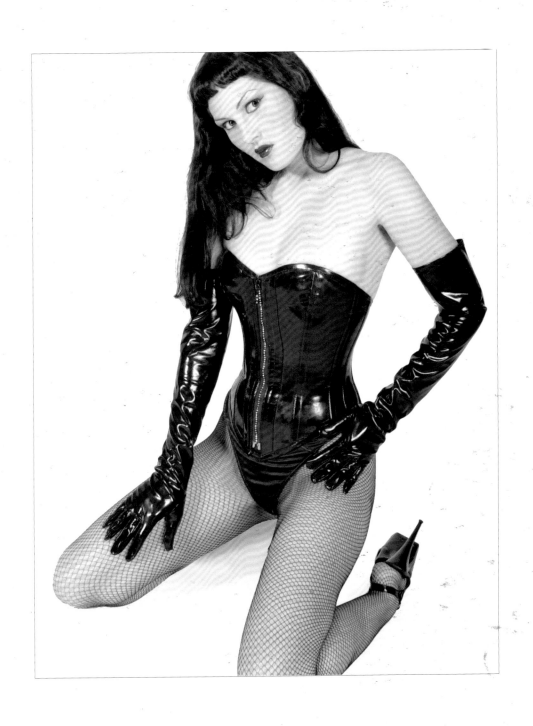

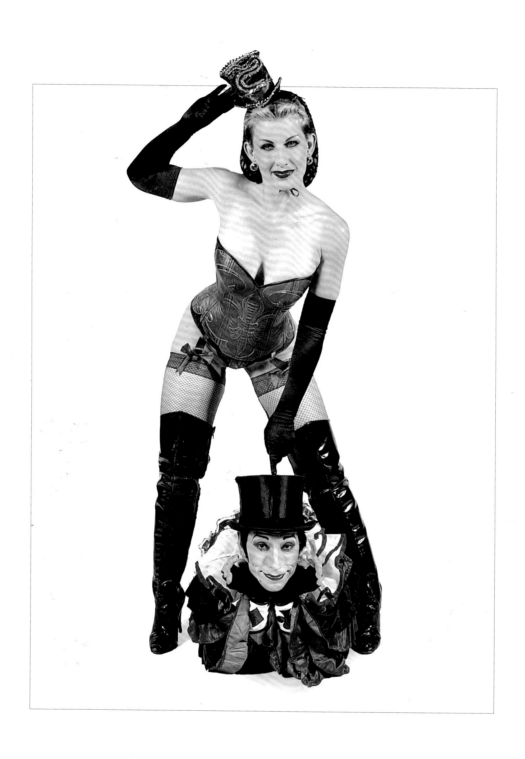

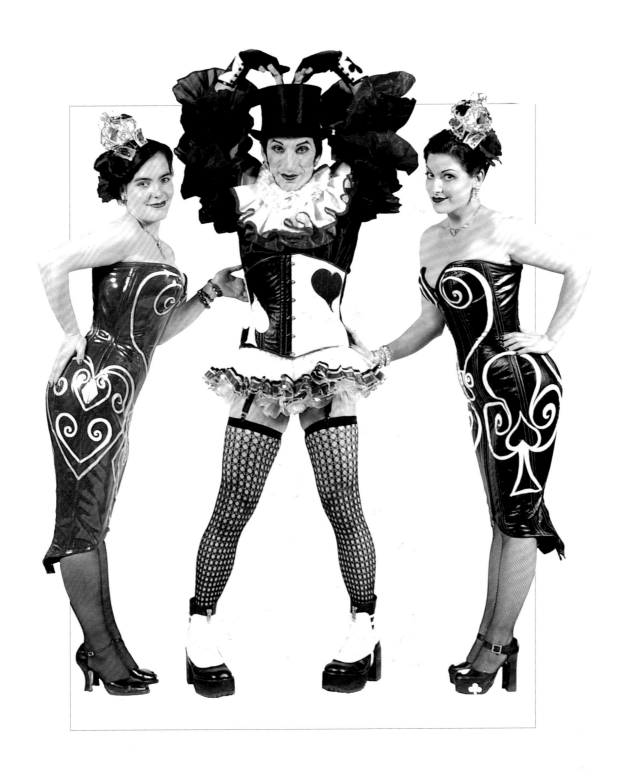

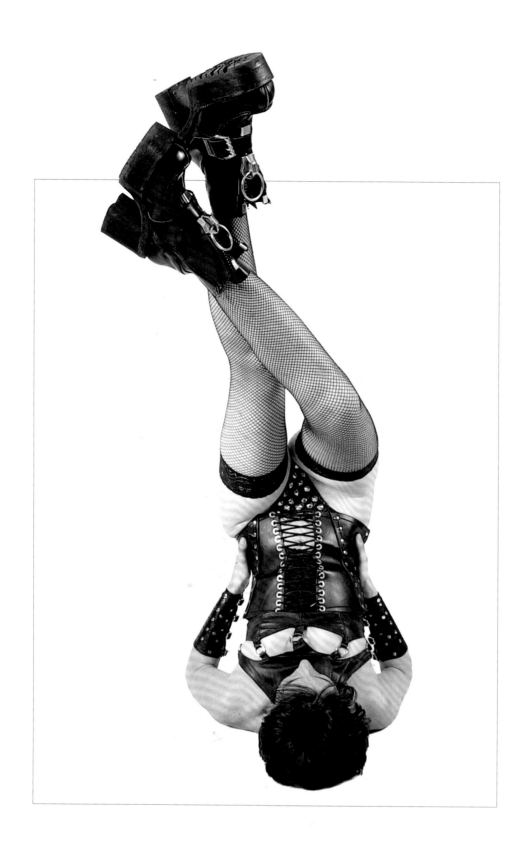

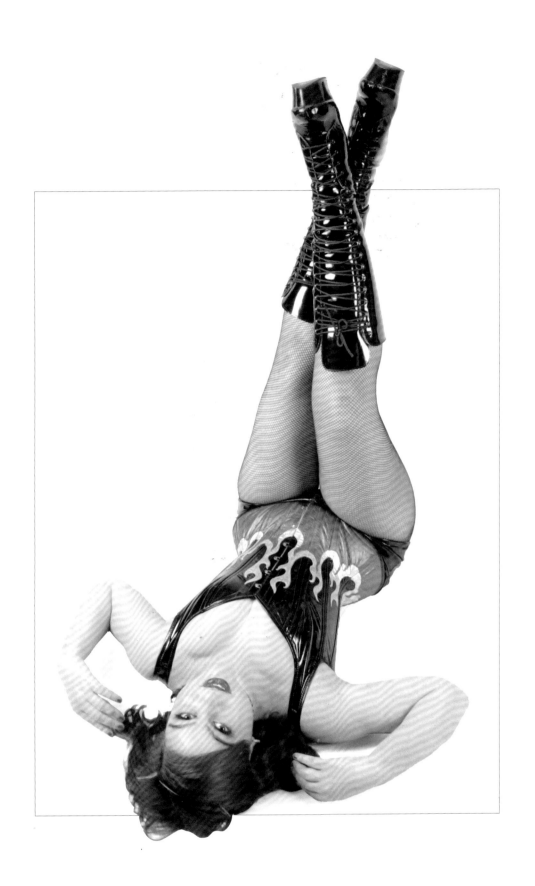

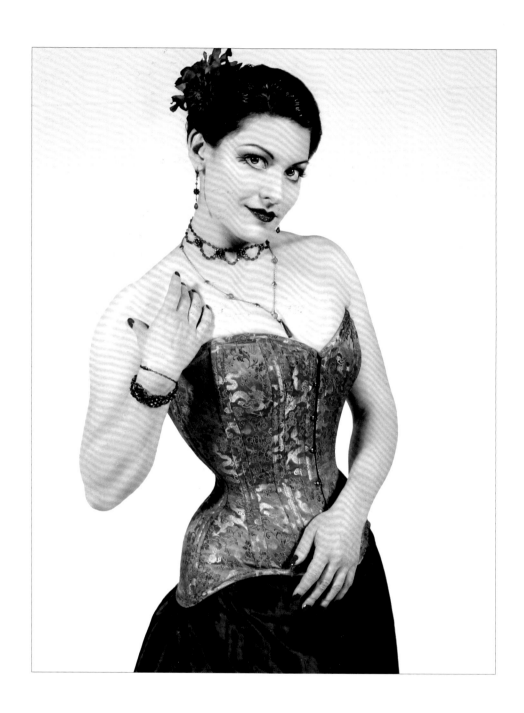

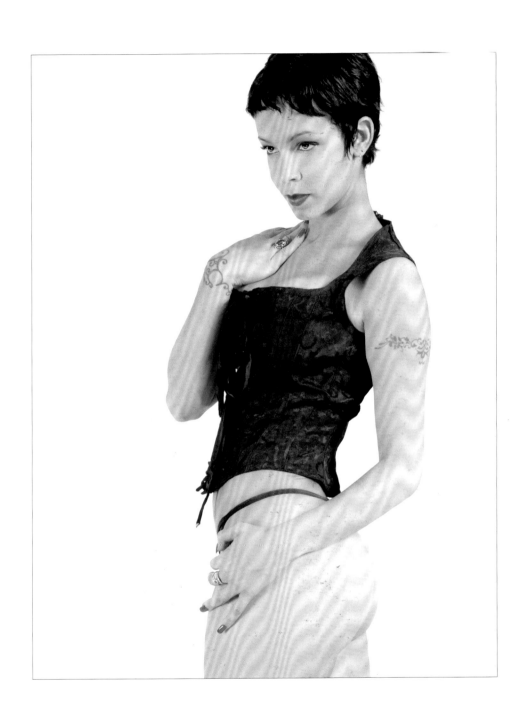

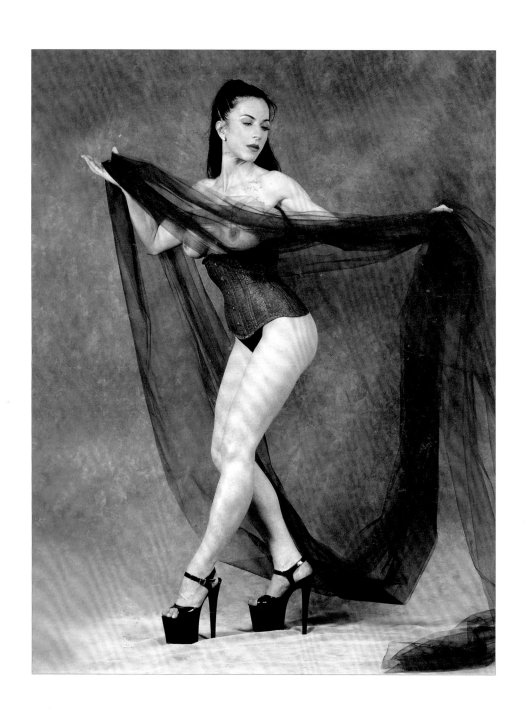

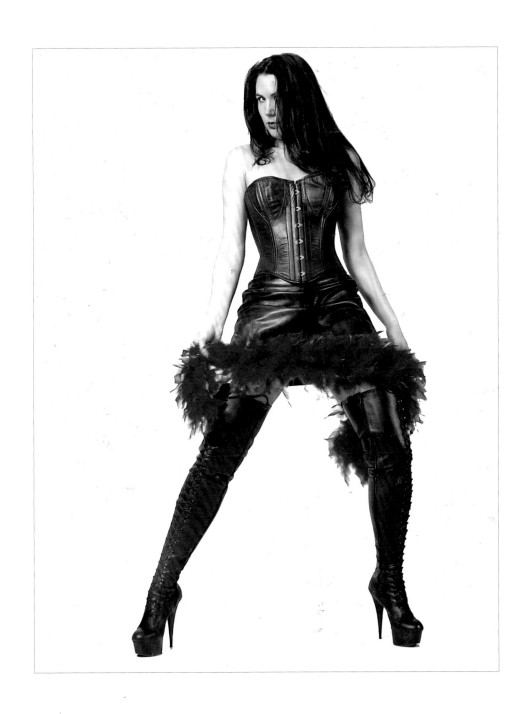

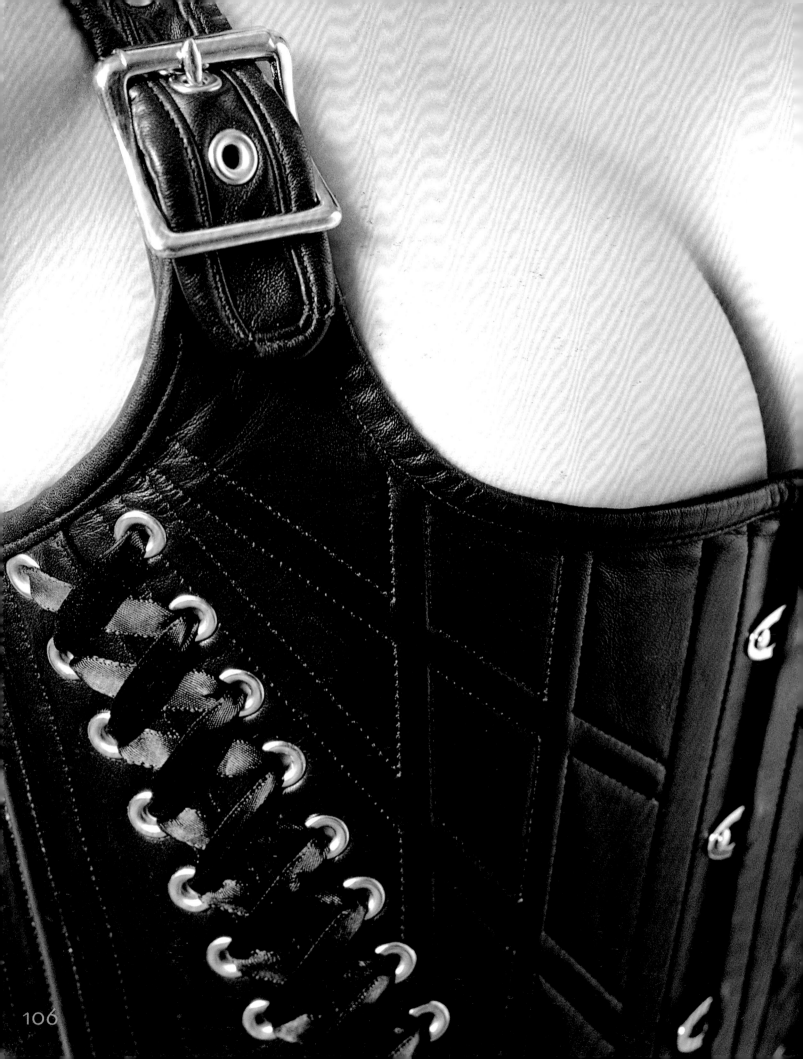

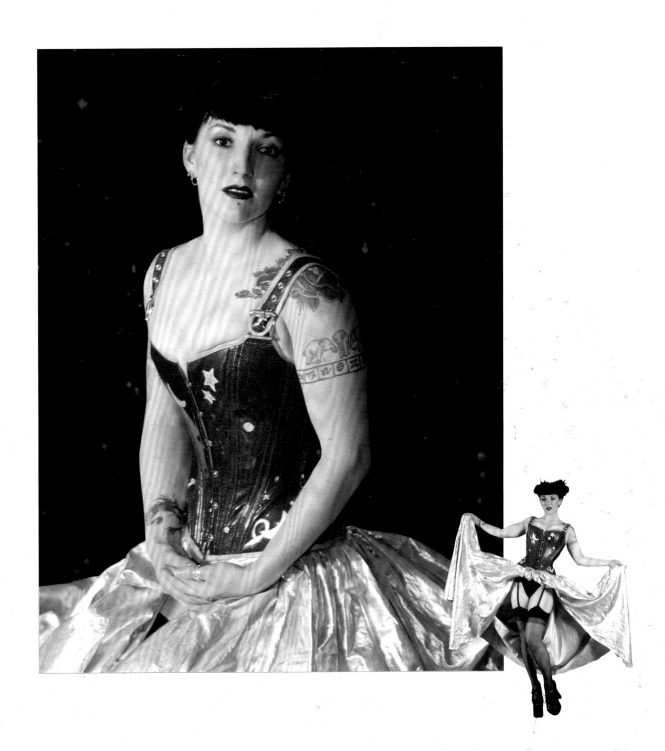

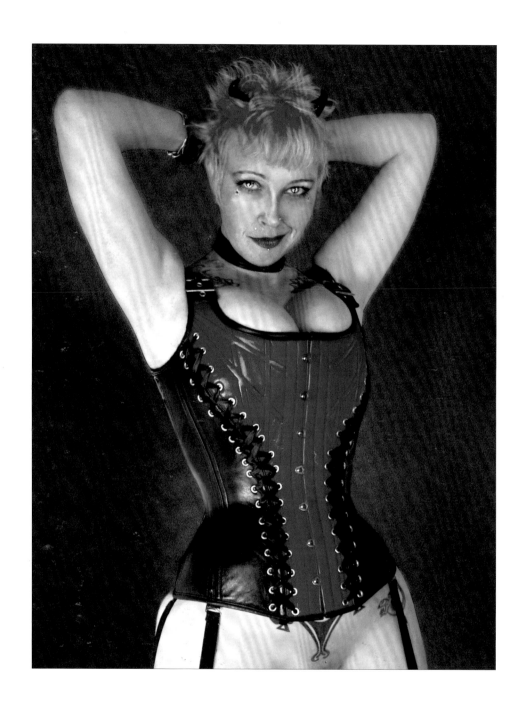

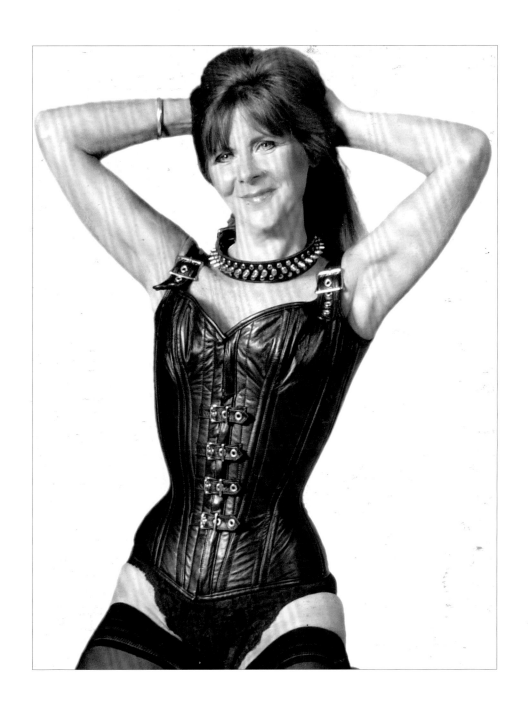

8 9 10 11 12 13

14 15 16 17 18 19

20 21 22 23 24 25

26 27 28 29 30 31

32 33 34 35 36 37

38 39 40 41 42 43

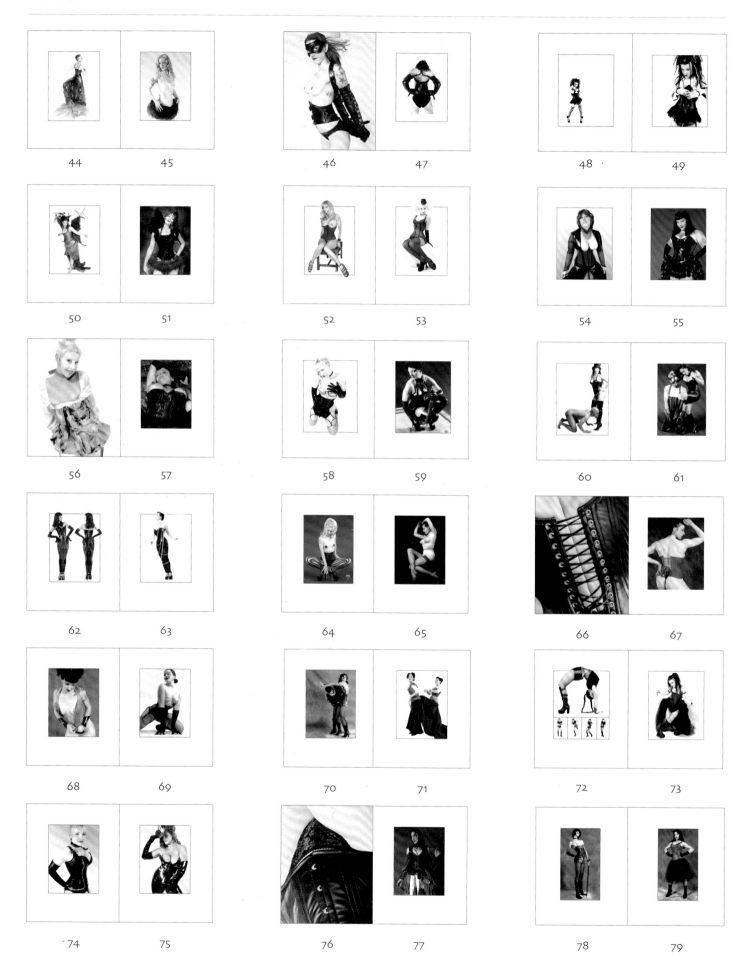

44　　　　45　　　　　　46　　　　47　　　　　　48　　　　49

50　　　　51　　　　　　52　　　　53　　　　　　54　　　　55

56　　　　57　　　　　　58　　　　59　　　　　　60　　　　61

62　　　　63　　　　　　64　　　　65　　　　　　66　　　　67

68　　　　69　　　　　　70　　　　71　　　　　　72　　　　73

74　　　　75　　　　　　76　　　　77　　　　　　78　　　　79

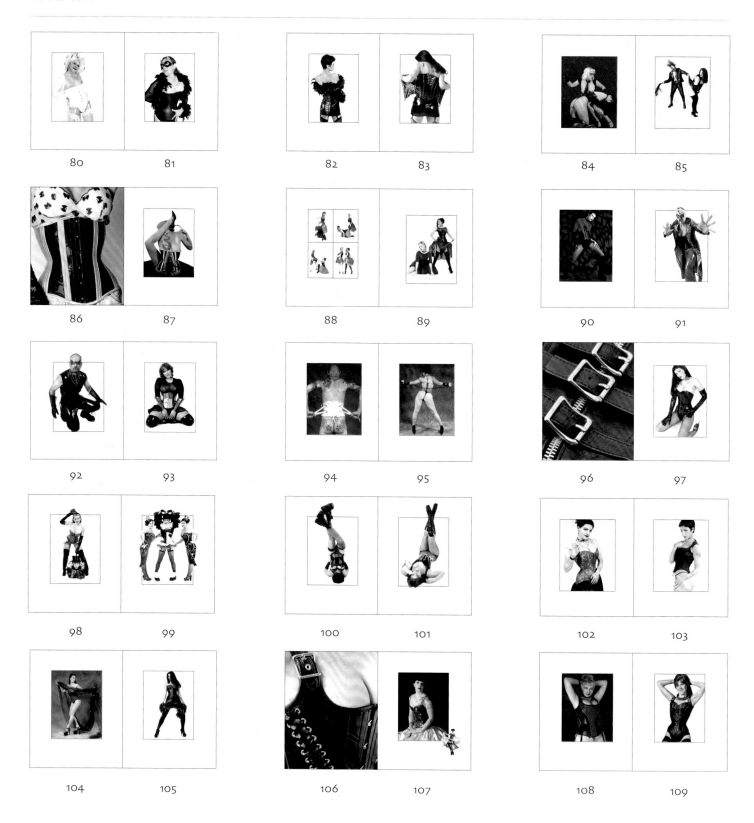

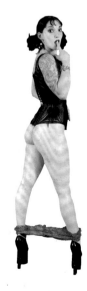